BASIC WATERCOLOR PAINTING

BASIC WATERCOLOR PAINTING

Judith Campbell-Reed

Line drawings by Fritz Henning

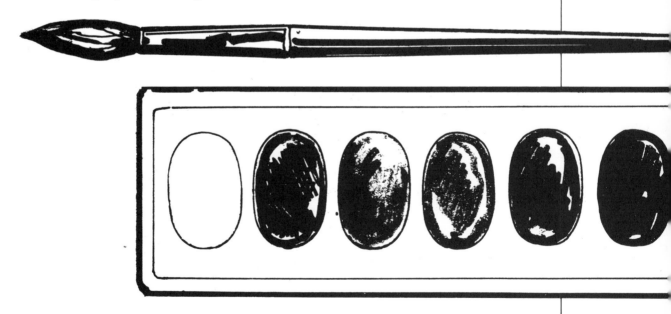

 NORTH LIGHT PUBLISHERS

Published by NORTH LIGHT PUBLISHERS, an imprint of
WRITER'S DIGEST BOOKS,
9933 Alliance Road, Cincinnati, Ohio 45242.

Manufactured in U.S.A.
First Printing 1982
Second Printing 1983
Third Printing 1986

Library of Congress Cataloging in Publication Data

Campbell-Reed, Judith.
 Basic watercolor painting.

 Bibliography: p.
 1. Water-color painting—Technique.
I. Title.
ND 2430.C35 751.42'2 82-6441
 AACR2

ISBN 0-89134-051-3

Edited and designed by Fritz Henning

This book is dedicated to my students.
Thank you for helping me learn.

Acknowledgments

Every artist is the sum of his or her experience. Our knowledge, skills and responses to life interlock like the parts of a puzzle. For me these parts are my teachers who have inspired me, friends who have supported me, and my family who understands me.

In one way, I owe my greatest debt to Priscilla Patrone, now painting in Wells, Maine, who first put a watercolor brush in my hand, and to Joan Dunkle who helped me push it around. These two women developed Bay State Workshop in Needham, Mass., and Art East in Wells, Maine, so that I and others could learn from the nation's finest watercolorists at a price we could afford.

Charles Reid, Barbara Nechis and Judi Betts helped me see beyond what was in front of me, and Liza Steig told me to "go clean my house" when my brush and my mind went dry.

Virginia Avery, Roz Farbush, Mary Lizotte and Ruth Ferrara who paint with me, and believe in me when I begin to have doubts.

My mother Annamarie has always believed in me, even though she tells me I am unbelievable. My sons, Ian and Colin, who put up with me and are my best critics and friends; and Bill, my old friend and new husband, who manages to hold the world at bay so I can work. To Melody Barlow, who has typed and re-typed, and most of all listened and understood, and rejoiced, a special thanks.

And finally, and with deepest appreciation, J. David Congalton, photographer, artist and friend. Dave gave of his tools, his expertise, his studio and himself to take and retake most of the color reproductions in this book.

Thank you all for all your help. For without YOU, the idea, not to mention the book itself never would have come into being.

Contents

Preface

The idea for this book came about when a group of watercolorists and teachers of watercolor were sitting around bemoaning the fact that, in our opinion, a totally basic book of watercolor instruction simply did not exist. Many good introductory level books are available, but all assume some knowledge of color, composition, drawing and/or materials.

As a teacher, I specialize in beginners. I like beginners, perhaps because their progress is so dramatic. It makes me feel so good to see their success and their pleasure with that success. I also am firmly committed to the idea that just about anyone can paint or draw if they want to give it a try. My only qualification for students is that they be able to hold a brush and push it where they want, and that they have enough visual and mental acuity to be able to read and write their own names.

I remember my friend and first watercolor teacher, Priscilla Patrone, holding up a brush and saying, "This is the fuzzy end!"

That is how basic this book is. In it I have tried to reduce every step, every movement, and every process to its most understandable components. This is because I have had the experience of feeling "all washed up" before I had half begun.

For some reason people fear watercolor, perhaps because some sadist one time started the rumor that watercolor was an elusive mistress and could only be controlled by the very gifted and elite among artists. I find this interesting because with a few notable exceptions, J.M.W. Turner and, later, Winslow Homer, to mention two, watercolor was not considered an art form in and of itself until this century. Previously it was a sketching medium, or a pastime for wealthy Edwardian and Victorian ladies. It was not to be given its rightful place until fairly recently (historically speaking, of course). One need only to look at the proliferation of watercolor supplies, paints and brushes in art stores to see the trend.

I came to watercolor after eight years of oil painting. I was looking for more spontaneity in my expression...and I found it. But I found it after many frustrations that were not necessary had I been able to find a book like this one. My teachers were vital, but we are not in class twenty-four hours a day, so when disaster strikes we are usually alone.

This book is planned as a guide, a reference, a teacher and a support. The message is that you can do it...here's how...and here's what to do when inexperience strikes, and disaster follows.

So to you, the beginner, and to you, the more experienced, I offer my words and my experience. I have made many paintings and *all* of the mistakes known to man and woman. Because I have made so many mistakes, I know how to gracefully get out of trouble...I've had lots of experience. Go forward and try, and remember what my artist friend Ginny Avery and I always say: "If you are going to make a mistake, make a whopper! Little ones are hard to find, and you don't learn as much from them." Do it!

Introduction

Learning watercolor painting is much like learning to drive a car. The beginner is usually nervous, afraid of making a mistake, confused with the myriad things to remember, and convinced the skill is beyond mere mortal attainment. The difference is that most people feel a strong need to learn to drive and, thus, they persist.

Painting is not a survival skill—although there are some of us artists who would disagree. Yet it is a skill that will give you endless hours of joy, release, occasional frustration, and in the concentration that it demands, freedom from the pressures of the world around you for a while—and it doesn't cost $75.00 per hour!

The purpose of this book is to take the true novice through a series of carefully planned and structured exercises that will teach basic skills and techniques, and, at the same time, produce a finished painting with each chapter. The secret of success for the beginning painter using this book is to read each chapter all the way through before starting to paint. Then assemble *all* of the materials in the manner directed, skim the chapter again for a sense of where you are going and how we plan to get you there, and only then begin.

You may have noticed that I use the words "skill and technique" rather than "creativity and talent." It is my opinion that the making of art, in this case watercolor paintings, is a skill that is comprised of a variety of techniques that can be learned by anyone with the ability to read this book and possesses but a morsel of manual dexterity. The speed with which you acquire these techniques depends on your available time, your interest, and your determination.

One of my private goals in teaching and in my painting is to dispel the myth that the artist is born that way — and all others

need not apply. It simply is not true. I agree people in general have inclinations — natural ability, if you will—toward drawing, music, mechanics, or math, for example, but the basic skills in any of these disciplines can and must be learned. When I state that you, the reader, can learn painting skills, I am speaking from my own experience first and foremost as a learner, then as a teacher specializing in beginners, and finally as an artist. In fact, this artist as a child and young adult had no major plan or "calling" to be an artist. Painting is something I learned, and when I learned I was good at it I continued and succeeded.

Many of my students, following the same exercises outlined here, are now showing and selling their paintings. It is a wonderful feeling for them and for me. But the important part is that they felt the same fears and trepidations as they began to paint as any new learner feels. They made some soggy disasters, learned from them, and tried again. Soon their results were amazing to me and themselves. Although at first they were convinced their work was just "beginner's luck," repeated efforts and successes proved luck had very little to do with it.

Once in a while a painting seems to fall out of my brush with very little help from me. Those occasions are rare and to be treasured, but not to be expected. Some of my best paintings are ones that I have struggled with and finally won. One example that remains forever in my mind is of a painting that started as a "sunrise-snow landscape," was washed out six times, and ended up as a "night-snow landscape" because with each successive washing out I had to go darker to cover up the rapidly accumulating disasters. The finished painting looked good and when I delivered it to one of my galleries, the director laughed at my asking price and tripled it. I suggested that he needed the services of a skilled counselor. He had the last word, however, and sold it two weeks later. So much for the myth that people can't make mistakes in watercolor painting. If that were the case, I would have given up long ago.

I often say to my students, "Don't let an accident, or mistake, throw you. No one cares that you goofed, but they'll be impressed when you turn a goof into an advantage." Marvelous paintings

have developed out of an unplanned waterspot, scrape, or, in my case, paw prints left by an exploring cat! If a painting has some good elements in it, work with them. I am not a purist as you will soon discover, and if three-quarters of the painting is good, a little minor (or major, in some cases) surgery may save the day and give you a good painting. Cut away the bad piece and throw it out!

And while on the subject of throwing it out... There are times when you should do that. Experience will help you know when, but a guide for the beginner is to throw it out if the painting seems to be getting more hopeless by the minute. Throw it out or wash it off or, in some way, get rid of it. I know we were always taught to finish what we started. My mother's words, my New England heritage, Puritan ethic tell me this — indeed, haunt me — but the axiom "when in serious doubt...dump" is a good one. If you allow yourself to become hopelessly defeated by a bad start that leads to a worse finish after several hours of soggy frustration, you'll be less willing to start again. Chalk it up to experience, wash it off if you can, put the little monster away where you can't see it and take a walk! It is only *a piece of paper*. Sometimes we are constrained by the cost of the materials and our own determination to make every stroke count. I wish I could do that, but I can't. Why should you?

If you use a good quality paper such as the Arches 140 lb. cold press as I suggest, you can always use the *back*. When the washed out disaster has dried, use the remains as the start of something else — *several* days or weeks later. Don't go back to it immediately! If worst comes to worst, you can always cut disaster paintings into small pieces and use the abstract patterns as greeting or post cards. The paper is heavy enough to go through the mail. (There now, how's that for "Yankee ingenuity" and economy!)

Now that our tone is set, relax, get comfortable, and remember, painting watercolors is eminently doable. Let's begin.

1

Materials — things you buy and why

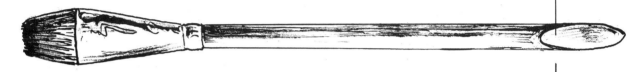

Brushes

> 1-inch aquarelle (flat) by Grumbacher or Morilla — This is a must! Don't buy a white acrylic bristle brush; get a natural animal hair brush for this.
>
> #12 Round — As soon as you can afford it, get this. The white artificial hair brush is good and inexpensive. It is *very* useful.
>
> #4 or #5 Rigger — This is not too expensive and it is handy for grasses, branches and boat rigging.

Your brushes are a big investment; buy the best you possibly can. A good brush will do what you want it to do, will last a long time, and will be your friend for life. A bad brush is a constant frustration.

Paints

Once again, buy the best. I always use Winsor-Newton artist quality. They are expensive initially but the colors are more intense and will last longer and go further than less expensive brands. Of the less expensive brands, the Hunt-Speedball is quite acceptable and they have a good range of colors.

Colors

This is a basic list. We will use these colors throughout the book. You may choose to purchase others, but these are a must for proper results:

- Alizarin Crimson
- New Gamboge or Cadmium Yellow Light
- Antwerp, Winsor Blue, or Prussian Blue
- French Ultramarine Blue
- Warm Sepia or a good, rich, dark brown
- Burnt Sienna
- Raw Sienna or Yellow Ochre

This is a basic palette. You will be able to *mix* almost *any* color you will ever need with this palette.

Paper

For beginners, I prefer Arches 140 lb. cold press. This is a medium weight, 100% rag paper with a slightly rough surface, but most important, this paper can take *abuse*! If you make a mistake or have a difficult area in a painting, this paper takes scrubbing out and washing out better than any other one with which I am acquainted. Arches has two good surfaces, too. If (heaven forbid!) you really have a disaster on one side and you can't wash it out any more, there is always another usable side.

There are many papers available today, and there are several books that describe them in detail. My advice is to become comfortable with Arches 140 lb. cold press and comfortable with the techniques demonstrated in this book, then go and buy sheets of different kinds of paper, tear them up and experiment. You may find a surface and a weight you like better. Take notes on your findings. You might forget later on... But in the beginning it's wiser not to worry about finding the right paper at the same time you are learning how to hold your brush and deal with paint that is sliding all over the place. One step at a time.

The above items are things you must purchase. The rest of the materials/supplies generally used by watercolorists are odds and ends you will probably have around the house. So get out a basket and start collecting.

Two plastic containers (ice cream, yogurt, etc.) for water; one for
the first rinse and one for the second rinse and clean water.

An old credit card for making rocks, grasses, tree limbs, etc.

A sponge or an old cotton towel or diaper for blotting excess water
from brushes.

A natural sponge — a painter's sponge, not a smooth textured
one. These are available at hardware stores and are used to
paint trees, bushes, flowers, etc.

A single-edged razor blade for rocks, grasses, tree limbs, etc.

A roll of waxed paper to cover areas or wax resist.

Some kosher (coarse) salt.

An old towel for wiping off a brush before rinsing it (which will
keep your rinse water clean longer). It's also good for
blotting water out of a brush and for wiping your hands.

Some junk white paper to test colors and ideas.

A pencil.

A kneaded rubber eraser — Any other eraser may mar the surface
of your paper or deposit rubber crumbs on everything.

A palette — You can use anything with a large mixing area such as
a butcher tray, commercial palette or a plastic, divided, dispos-
able dish. Make sure it's white so you can see the colors you
are mixing.

A 12 x 16 inch sheet of masonite or corrugated cardboard.

A roll of ¾ or 1-inch masking tape.

A blow dryer (handy but not required).

Some bulldog clips.

Tissue — A roll of toilet paper (cheap) or a box of tissue for tex-
ture, clouds, mopping up spills, creating patterns, blowing your
nose, etc.

This is a basic list. As you work you will find other things that
are indispensable to you and incomprehensible to me. The reverse
may already be true.

Now that I have you "armed to the teeth" with paper, brushes,
paint and junk, the next consideration is where you go from here.
Most of us do not have a huge studio with north light, free from
kids, cats, dogs, telephones and other intrusions, and overlooking

an inspirational vista when we first begin. One artist I know has a fold-down desk in her kitchen; another converted a closet. I painted in the kitchen and then the dining room for years. Reason: a table!

One of the benefits of watercolor over other media is that it really is quite portable, compact, dries fast, and can be stowed away in short order. (I painted with oils for eight years before switching to watercolors, and wet oil paints *do* present a storage problem if you don't have a private studio.)

Your own table in the corner of a den or bedroom can also make a good studio — and since the idea of a studio is in the mind of the artist, almost anywhere with reasonable light (natural or artificial) and out of the general traffic pattern of your home will suffice. (One artist I know painted on the coffee table in her living room after her kids went to bed. It was the only uncluttered spot in the house.)

A flat door on legs or sawhorses makes an excellent painting table. You don't have to worry about the surface (as you would a dining room table, for example) and you can really spread out. A 3 x 6 foot surface is really good, but artists have made do for centuries, so, make do!

I prefer to paint standing up. If health problems won't permit this, find a way of putting distance between your eye and your paper. When you are working too close to your painting, you tend to use your small muscles, as in handwriting, and the painting can become "tight" or "rigid" from the very beginning. You want to be away from your painting so you paint with your whole arm — in fact, your whole body.

It should be noted I am at all times referring to studio (in the house) painting rather than painting "on location," or painting *in* nature. I am primarily a studio painter. I get irritable with flying leaves, bugs, and the inconvenience of not having absolutely *everything* at my fingertips. (Perhaps the word is spoiled!)

Now you are ready to start. The last of the materials you will need are not material at all, but spiritual. And they are every bit as necessary as paper and paint.

The first you already have or you wouldn't be reading this: interest.

The second is an open mind. Under the heading "open mind" I can be more specific. *Forget* ANYTHING you ever heard or read about watercolor. You can make and fix mistakes easily (see splashdown — Chapter 13). You can start over. It is *not* a difficult medium to handle. It is not for practice, or only for sweet ladies who need something to occupy their time. Watercolor is exciting, occasionally unpredictable, and occasionally predictably unpredictable (planned accidents). It's fresh. It's immediate. It's what every child in us wants: instant gratification. I love it.

Another thing you should keep in mind is *feel free to fail!* Hardly an inspiring sentence. If you are going to make a mistake, make a whopper! Don't do anything by halves. The better the goof, the more you'll learn.

An instructor once asked me whether this was my first painting or my last. The implication is treat every painting as your first with many more to come. That way you'll have an open mind and not be afraid. If it is your last, you'll never have another chance. I'd hate to live my life that way.

The final thing I like my students to remember is that the empty white rectangle in front of you, the one so filled with unspoken promises and unstated beauty, is only a piece of paper! It should not strike terror to your heart. It may or may not be a successful attempt. As a professional artist I probably get one in fifteen that I am totally in love with, eight out of fifteen that I like well enough to show and sell, and six out of fifteen that I wash out, start over, or possibly even save for kindling. Do you read me? (I should re-read this paragraph at least once a day! I have trouble remembering, too!)

Fill up your buckets and let's go.

Setting up and Starting out right

Attitude is the most important "set up" you can have. You should paint when you want to, when you have an hour or more relatively free from interruptions, and when you don't feel pressured. My friend Roz Farbush once said in a lecture, "When I sit down to paint a masterpiece, I usually paint a mess. The pressure to be perfect is too great. But when I sit down just to paint, to play, and to experiment, I most often get my best results."

A preconceived idea of exactly how your painting will end up is possibly the worst handicap you can give yourself. This can't be emphasized too strongly. Start with an idea of the direction you'd like to go—subject matter, color, techniques, a learning experience—and then let it happen. Don't push it. The greatest part and the joy of painting is the *process*; the product is an after-image. If your process is good, your product will probably be good, too. But if you have already decided upon your outcome, any variation may frustrate you rather than lead you in an unexplored direction. I know it's especially hard in the beginning when dollar signs flash before you with every piece of paper and blob of paint, but you will go further faster if you can try to be "loose." With that, we begin!

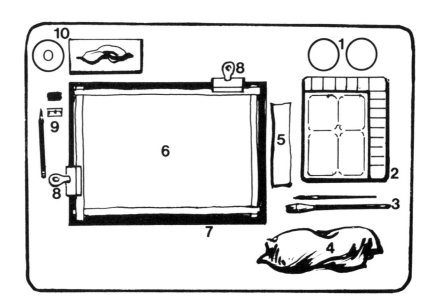

Here is a picture of my work setup. After years of experimenting this particular layout works for me.

1—Containers of water 6—Watercolor paper

2—Palette 7—Backing board

3—Brushes 8—Clips

4—Rag 9—Pencil, eraser, razor blade, etc.

5—Scrap testing paper 10—Tissue

1 Getting *everything* ready is important. You don't need to be flying around looking for something while your "wash" is drying up on you!

2 Preparing your paper — Arches 140 lb. cold press comes in "full sheets" (don't buy a pad) of 22 x 30 inches. To cut this into ¼ sheets you measure it and cut it with a knife or scissors *or* you may

fold and tear it. I prefer tearing because I like the look of the torn edge. Sometimes I flat-mount it with that edge showing. To fold and tear, first fold the paper down the middle and crease it. Be sure you work on a clean surface. Then fold it back and forth until there's a good, visible crease showing. Now tear slowly. It takes practice. Either way, cut your paper into four 11½ x 15 inch pieces.

Tape the edges of your paper with 1 or ¾-inch masking tape. This serves no purpose other than making a very nice, clean edge around your painting which helps to make the finished product look better. Frankly, in the beginning we all need all the help we can get, so do it.

Start by stretching the masking tape along the edges of the paper and even with the edge on all four sides. Overlap the corners and *cut away* the excess. Don't, don't, *don't* fold it over onto the back. This could result in a torn page. Another benefit of taping the edges is that it makes the paper easier to hold if you want to pick it up and run some water around — but you'll understand more of that in later chapters.

Once the tape is laid on, run the tip of your finger around the *inside* edges and smooth them down so no water will sneak underneath and give you a ragged edge. Also run your thumbnail along the inside overlap of the tape to prevent water from oozing under the seam.

Note: Taping is good for small paintings, but when you start getting bigger, such as 15 x 22 inches or larger, don't bother taping. Paint right out to the edges. Tape on larger pieces of paper can cause excessive buckling. Just clip the large paper untaped to your painting board.

When your paper is taped, place it on your 12 x 16 inch masonite — heavy cardboard will also serve — and clip the edges in place with "bulldog" clips. The clips are used instead of taping the paper down because when the paper gets wet it starts to buckle (get ripply) and you can let it expand by releasing the clips and then re-clipping it. By having your paper on a board you can lift or tilt it while working.

To tilt or not to tilt; that is the question. Some artists always paint on an inclined surface anywhere from 30° to 80° depending on their preferences. If you paint on an inclined surface, your water will always run down towards you. This is sometimes an advantage. I usually paint flat on my table and tilt the whole board by lifting and tilting it when I want to. But when I demonstrate for a large audience, I paint upright, almost 80°, unless I've been provided with an overhead mirror. My preference is flat or at no more than 30°. You should experiment to find the angle you like best.

3 Now you are ready to begin. Your water buckets should both be full of clean water. Check to make sure your brushes have no old paint hiding in them, have a piece of tissue handy. And...read *every* word of the next chapter before you do anything else! This is an important step in the process. You have to know in advance what the whole process is. You needn't try to memorize it, but the ideas should be familiar to you.

Look again at the table set-up picture. It is arranged so that you will carry your brush from your water down to your palette, across your towel or sponge if you need to get rid of excess water, up to your test paper, and only then to your paper. The reason for

this direction of movement is so that you won't splash or drip unplanned "plops" on your painting. Get in the habit of moving your brush in that direction. (If you are left-handed you may wish to reverse the position so that the water, palette, etc. are on the left of the paper, and the other items shifted to the right.)

Before you begin, always squeeze out all of the paint colors you are planning to use. If you have a permanent palette as I do with twenty or more colors, wet them down or refresh the containers *before* you begin. It's difficult to fight with a stuck paint tube cap while your sky is drying. If your tubes are stuck shut, hold a lighted match underneath for a *few seconds* and they should loosen. Pliers are sometimes useful in this freeing operation. There may be times no matter what you do the stuck cap won't loosen. As a last resort you can always cut it open and get at least one more painting out of it.

Check your light source. It should be diffuse, but bright enough to let you see the colors correctly. Don't position yourself either in direct sunlight or so that you cast your own shadow on your work.

And now...Go forth and bring into the world a new painting.

Painting — sky and landscape

You need:
 1 quarter sheet Arches 140 lb. cold press paper (11 x 15 inches)—edges taped with masking tape
 1-12 x 16 inch piece heavy cardboard or masonite
 1-inch flat aquarelle brush
 2 filled water containers
 Tissue
 Old towel
 Palette
 2 bulldog clips

 Colors
 Blue—Antwerp, Winsor, Prussian, or pthalo blue
 Yellow—New Gamboge, cadmium yellow light, or raw sienna
 Brown—warm sepia, sepia, or burnt umber (or a dark brown)
Refer to Chapter 2 on how to arrange your work area.

Clip taped paper to cardboard or masonite with ½-inch margins on all sides.

Squeeze out some of each color onto your palette. A blob of each color about the size of the tube cap will suffice.

You are ready to begin.

Start your first painting by taking your clean brush, dipping it into clean water and thoroughly wetting the entire surface of your paper. Brush water over the surface several times, swishing your brush in all directions. Lift up the support board (cardboard or masonite to which your paper has been clipped) and hold it at an angle away from you and see if you have missed any spots. If you have, wet them. The paper should look shiny, as it actually has a thin film of water floating over the surface. This film will help to

Graded wash

carry your paint into the pleasing patterns we want for this painting.

After the paper is shiny take some tissue and collect all the excess water that has beaded up on the masking tape. Also soak up any real puddles that may appear at the corners or across the bottom of the paper.

You are now ready to "lay in" your sky pattern.

Dip your brush into clean water and blot lightly on your towel. You want to have the brush wet but not dripping. It should be no-where near as wet as you had it for wetting down your paper, and not so dried out that you can't move the color into a pool on your palette. The proper amount of water in your brush will come with experience, but if you feel timid, try it once or twice before you start your painting.

With your wet brush, pick up some blue and mix it into a pool on your palette. If this blue seems a little bright for you, you may add a touch, a *very little* bit, of your brown to soften the intensity of the blue. (You are adding blue's "complement" when you do this.) When you get a blue you like, check to make sure your paper is still shiny. If it isn't, re-wet it with clean water. Take a good brushload of your blue, start at the top edge with your brush over-lapping the masking tape just a little, and with long strokes (one stroke going all the way from one side of the paper to the other) carry your blue paint in a series of horizontal strokes all the way down the paper. Your color will get lighter as you work your way down. *Don't pick up any more* paint; let it get lighter. Also, if you missed a spot and the paper shows through, *ignore it*. Don't go back and "play" in it. The water on your paper will float your blue into some of that space, making an interesting cloud shape for you.

What you have just done is called a "graded wash" and it means that you have gone from one tone or value of color to an-other in a reasonably even manner. In this case you have gone from fairly dark color at the top of your paper to lighter color as you worked your way down. (Notice that the sky above your head seems "bluer" than the color of the sky nearer the horizon.)

Your paper should look something like this. It will have your own individual variations of course, but if it is too dark or too washed out or too streaky, you can wash it off and start again. Do this by holding the paper under a faucet of running water. At the same time lightly swish it with your brush. If you want to start again, wash off as much color as you can, pour off the excess water, blot up the edges of the masking tape and the big puddles, and you can start all over.

When you have your sky area the way you like it (don't be too demanding of yourself at first!), you are ready to add your other colors and make the grassy area of your painting. This *must* be done while the paper is still wet; otherwise, your grassy areas will not bleed and blend properly. If your painting has dry spots, you can not continue. Wait until the paper is *completely* dry. The drying process can be hastened by blowing warm air on it with a hair dryer. Keep moving the dryer back and forth and around and

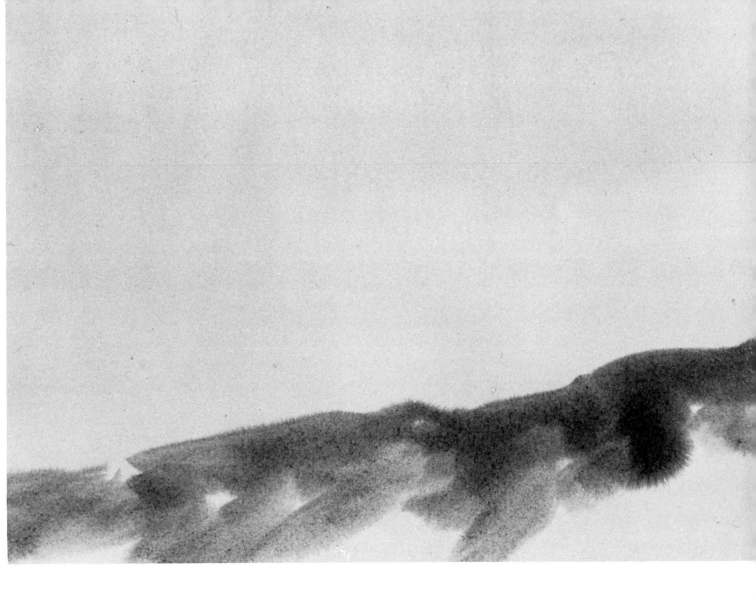

around so you don't dry out one area at a time. *Slowly and evenly*
dry the whole surface. Then rewet your entire paper with your
brush loaded with clean water in the same way you did when you
started. This will not disturb the color that has already dried. Wet
it quickly, don't scrub at the surface. When the surface is again
moist you are ready to continue.

Now, pick up a good glob of yellow with a wet but not dripping
clean brush. Swirl it into a puddle on your palette and add a
whisker of brown so your yellow looks a little muddy.

Starting *below* the middle of your paper and using your brush,
swish the color in a broad, uneven line all the way across your
paper from one side of the taped edge to the other in one stroke.
Now pull some of that color down to the bottom in broad patches.
This is your light pattern. Because your paper is still wet, the edges
will fuzz outward. This will eventually give the top edge of your
land pattern a distant, grassy look.

Now you are ready to add your green pattern. With the yellow still on your brush, pick up a *little* blue and swirl it into the yellow pool on your palette until you have a nice olive green. If your green is too bright, add a touch of brown to soften it.

If you find adjusting these colors too time consuming and your paper is drying out while you "fiddle around," practice a little before you start *or* mix up your color pools before you begin.

With your nice gooey green on your brush, swish the paint into your yellow pattern, sometimes touching the top, sometimes making some broad diagonal shapes, and carrying at least one shape down to the bottom. (Land patterns are never a uniform color; they are "patchy." You will notice this more and more as you gain experience in painting.) As you move your green shapes around, *make sure you leave some yellow shapes intact!*

#1

You are almost finished and are now ready to add some grassy texture to your green and yellow patterns to complete your first painting. Clean your brush of all paint and dry it out as much as you can by squeezing it with your towel. To suggest grass in your painting, twist your brush in the palm of your hand as in Illustration #1 so your brush looks like Illustration #2.

Flick the corner, not the flat side, of your smushed brush into the green patterns and pull up whiskers of green into your yellow patterns. If they blur at once, wait a few seconds till the paint dries a little, then try again. We want the paper to be drying out now. Do this all over your green and yellow pattern, drying your brush out and re-smushing it after every three or four flicks.

#2

28

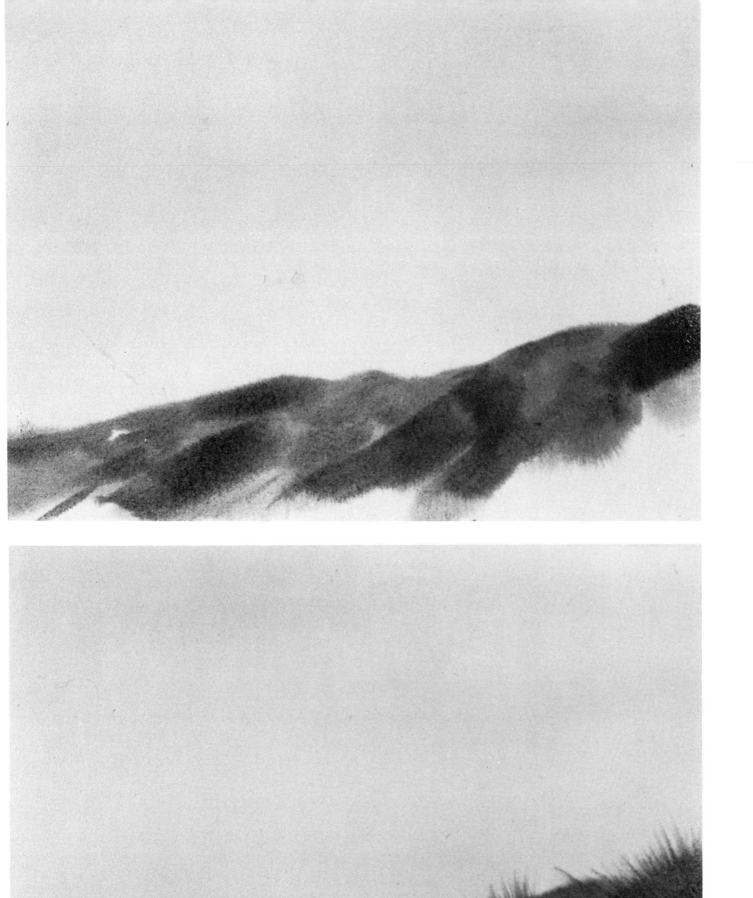

Grasses grow like this:

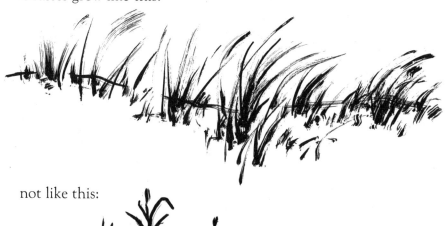

not like this:

If your painting looks a little bland, you can create some texture by scratching three or four large stalks of grass in the foreground (down near the bottom of the paper) using the back of your brush handle, the corner of a razor blade, your fingernails, or the corner of a credit card. This must be done while the painted area is still moist. Remember to "scratch" through the paint lightly, moving from bottom to top.

The next step is most important: look at your painting from across the room. It looks better, doesn't it? Most paintings look better from a distance. They were meant to be viewed that way. When we visit a home or a museum we don't press our noses against the painting (at least I hope not!). We view it from across the room. This is what the artist intended. As you look at your painting from a distance, you can tell what's good and what needs work. For your first painting, don't do much more. Rather, move on to another one. Either repeat the entire exercise or go on to the next

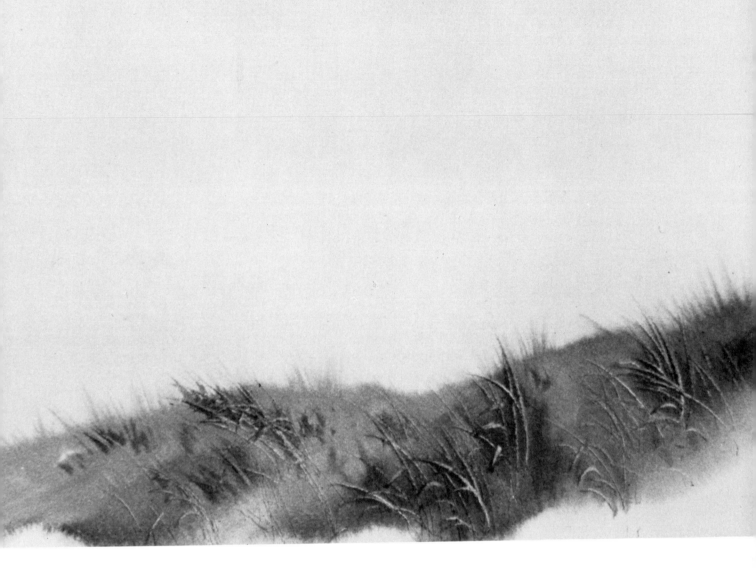

chapter, but don't overwork either the painting or yourself. All
this takes practice. Whenever I learn a new technique, I practice it
twenty or thirty times before I feel comfortable with it.

Let your painting dry completely before removing the masking
tape. When it is dry, with clean hands, peel up one corner of the
tape and slowly pull it off. Pull away from the painted part of the
paper so the tape comes free at about a 45° angle. If the tape lifts
the paper, it will tear *outward* instead of into your painting.

Removing the tape has a magical effect on your painting. The
white border looks like a mat and makes your completed piece look
much more professional and finished.

Final touches: Look at your painting. Is the sky too bland? Are
there a couple of unplanned splatters that are noticeable? With a
landscape painting such tiny accidents can be effectively masked
with the addition of some well-placed birds!

If you plan to add some birds to your painting, remember the following:

Birds don't look like this

or this.

The best all-around "bird" stroke is a wide "V" in a middle value. A mid-value is any color that is about half way between the lightest light you use and the darkest dark. You can "print" the wide "v's" with a touch of your aquarelle brush, but it is easier to "draw" them with the top of a tiny brush, or the corner of your aquarelle. Draw from the inside out and it's okay if they don't meet in the center. If they look too dark, blot at once with your tissue. You can check the position by drawing them in lightly with a pencil before you paint or you can just use your pencil and not paint them at all if you feel too timid. It will look okay in the beginning. Later you will feel more adventurous.

Remember, most birds fly in all directions, and should generally create a *random* movement in your sky area, unless, of course, you wish to suggest flights of ducks or geese in formation.

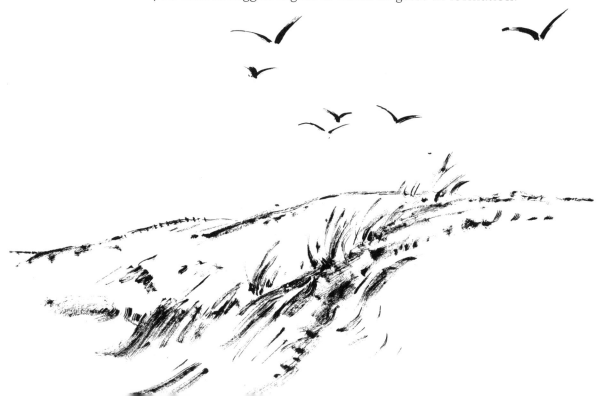

Here it is—your first finished painting. It should only resemble this, not be a carbon copy. Already you are putting yourself into it: you are blending colors, controlling your brush stroke patterns and making marks that suggest birds.

The technique we have just utilized is called wet-in-wet painting. We painted almost the whole painting at once, using the water to carry the colors into accidental and pleasing patterns. Later on you will learn how to direct some of these accidental flows into more planned directions. Wet-in-wet is a commonly used technique in watercolor, and in the gallery section you will see another example of its effectiveness.

As I mentioned earlier, resist the urge to fix-up, fix-up, fix-up. It is your first painting. You will, of course, see areas you really like and areas you'd like to improve. Try to include the corrections in your next painting.

Painting — sky, grasses and rocks

Here is a good practice exercise to get you relaxed.
You need:

Some scrap Arches 140 lb. cold press — the back of an old
 painting will do, or use a special practice piece which doesn't
 need to be taped
1-inch aquarelle brush
Water
Old credit card or single-edged razor blade
Any color of paint (except yellow) *or* your dirty palette—in
 other words—use up old stuff.

Wet your brush and make a patch of fairly intense color about
3 x 5 inches on a dry piece of paper. If the paint is runny and
puddly, wait until it is just beginning to lose its shine. Using the
side (not the tip) of an old credit card or single-edged razor blade
held at a 45° angle to the paper, push away some paint by pulling
the credit card through it to reveal rock-like forms showing
through in the mottled texture of the paper underneath.

This takes practice. Avoid digging lines with the tip of your
razor blade or card. That will make dark lines that look like cro-
quet wickets and not much like rocks.

Remember, there are not many straight lines in nature; rocks
are most often jagged.

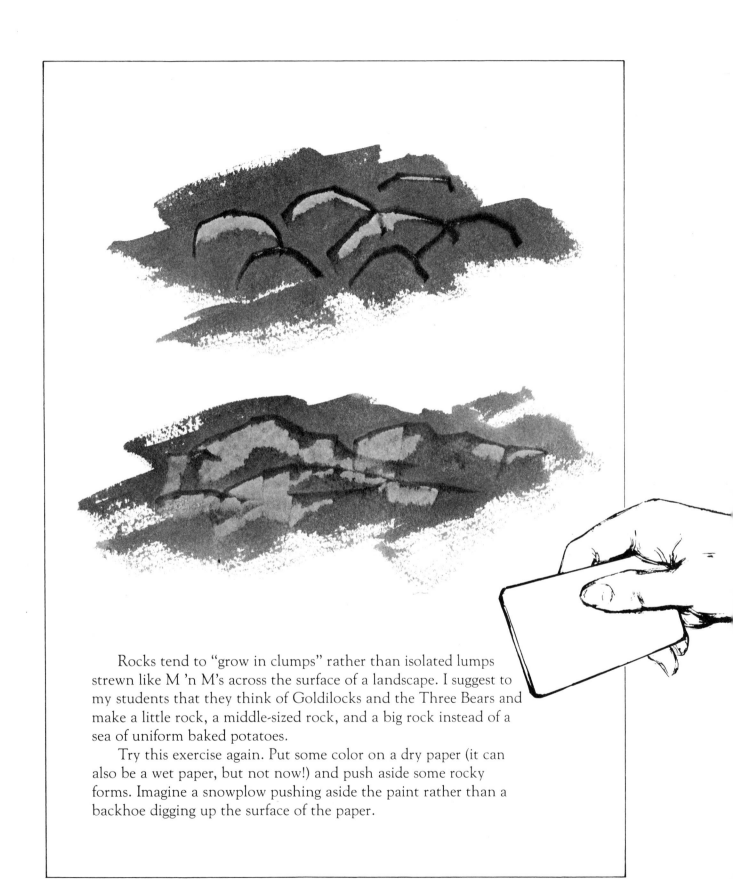

Rocks tend to "grow in clumps" rather than isolated lumps strewn like M 'n M's across the surface of a landscape. I suggest to my students that they think of Goldilocks and the Three Bears and make a little rock, a middle-sized rock, and a big rock instead of a sea of uniform baked potatoes.

Try this exercise again. Put some color on a dry paper (it can also be a wet paper, but not now!) and push aside some rocky forms. Imagine a snowplow pushing aside the paint rather than a backhoe digging up the surface of the paper.

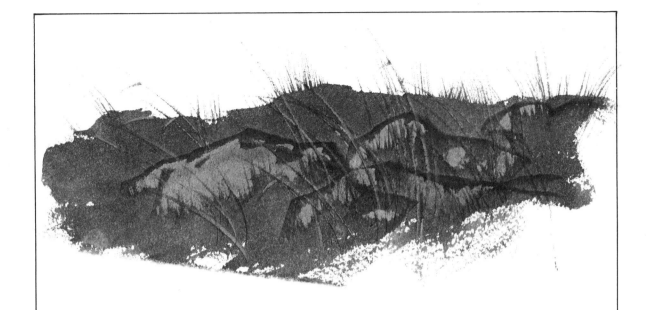

You can even smush your brush and grow some grasses out of the wet paint at the base of your rocks as you are practicing.

If your rocks fill in at once with paint and seem to disappear, your paint is too wet. Wait a minute or so and try again. Remember to *push* the paint (as you pull the credit card or razor blade). Do not scrape. If you have just pushed the paint aside and not damaged the surface of the paper, you can get rid of an undesirable rock shape by painting it right back out! If you scrape the surface of the paper, that rock is with you forever.

After you practice this a few times, you are ready to start painting #2.

You need:
 A taped quarter sheet of Arches 140 lb. cold press paper
 clipped to cardboard or masonite
 2 filled water containers
 1-inch aquarelle brush
 An old credit card or a new single-edged razor blade—make
 sure neither the credit card nor the razor blade have nicks
 or you may get unpleasant scratches
 Old towel
 Tissue

Colors

 Blue—Antwerp, Winsor, Prussian, or pthalo blue

 Yellow—cadmium, New Gamboge, or raw sienna

 Brown—warm sepia, sepia, burnt umber, or any dark brown

We will proceed with this painting in the same way we did with the first one, using again the "wet-in-wet" technique. We'll use the same colors, but altering them somewhat by mixing the pigments in different proportions.

Squeeze out a little of each color on your palette.

Wet your paper thoroughly as before, tilting it away from you to check for wet spots and blot the edges with your tissue paper.

With a wet but not dripping brush, take some blue and swirl it into a puddle of about middle value on your palette.

Too pale *Too intense* *Just about right*

This time, instead of starting with a graded wash, make three long, unconnected strokes across the top.

Pick up your paper clipped to your board and tilt it at an angle so the colors run. When the pattern is pleasing to you, quickly lay it flat again. This is your sky pattern.

Clean out your brush and while it's still wet, pick up a little yellow and mix a light puddle. Add a touch of brown so that you have a light gold tone.

Too yellow

Too much brown

Just about right

Starting above the center, about one-third of the way down from the top, brush in a slightly irregular line across the paper, ending slightly lower than you started. Pull some color down in an irregular pattern. This is your light foreground area.

With the paint still in your brush, pick up a glob of yellow and swirl it into your yellowish puddle. Add a little blue and a little brown until you have a rich gold-green that's not too dark or intense. If your paper starts to dry out in spots, let the *whole thing dry*. Then rewet with clean water and continue.

Too pale

Too blue

Just right

Work a green pattern into your yellow pattern the same way we did before, sometimes touching the top of the yellow, sometimes coming all the way to the bottom, but always leaving some good-sized patches of yellow for the nice "patchy" effect we see on an untamed rural hillside. By the way, in this painting it's all right to leave some irregular white (unpainted) patches at the bottom edge of the painting.

With the color still in your brush, pick up a little more brown and swirl it into the green puddle so that it gets much "browner." Don't add more water to do this unless you can't get the color to mix at all. If you must add water, add only a *very little*.

Too pale

Too intense

Just about right

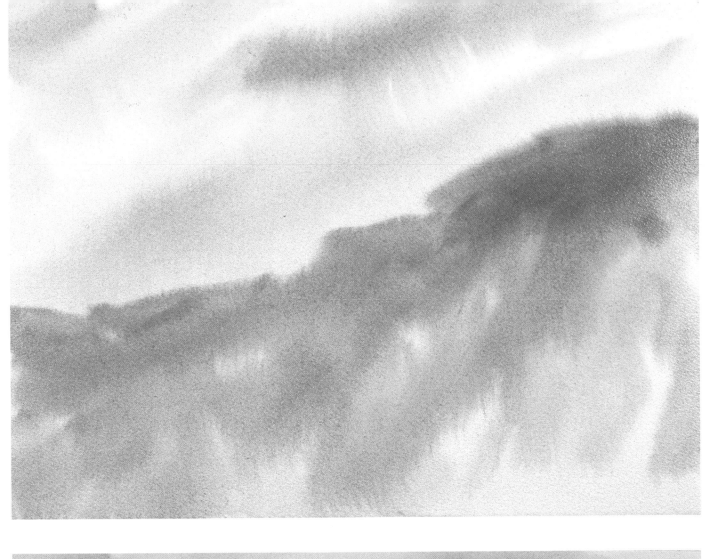

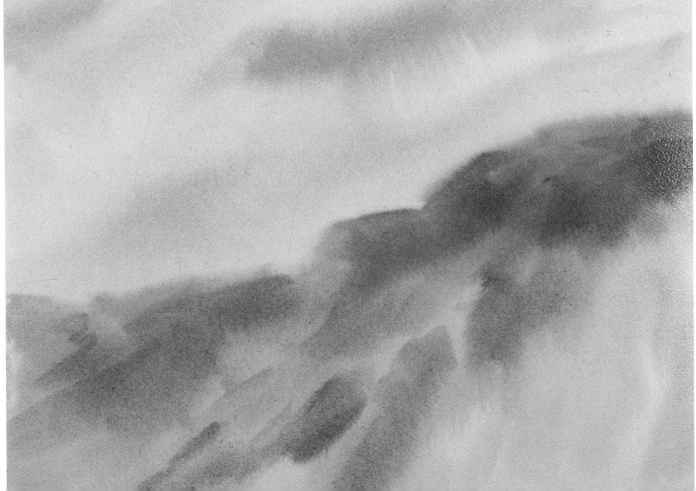

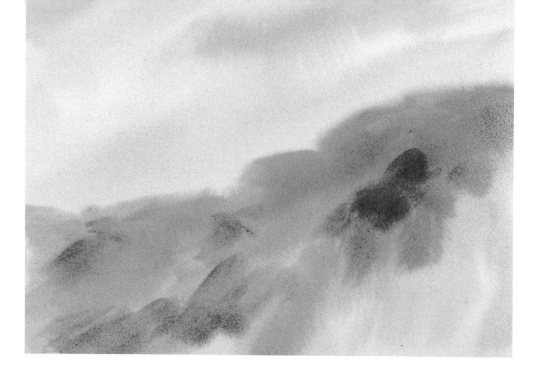

Make a brown pattern, but make it a small and scattered one of a few touches up near the top of your hillside and a few larger touches coming down toward the bottom. In doing this, try not to make a brown "X" or a brown diagonal ski jump in the middle. Strong, recognizable geometric shapes appearing in landscape compositions are distracting and tend to divide your painting. Such effects should be avoided.

Now you are ready to add your rocks. The paper should still be quite wet if you have worked quickly. If the sky is dry, that's alright, but you need the grassy area to be just losing its shine. Remember to group your rocks rather than isolate them, take your credit card or razor and push aside some paint in a rock-like pattern. Put some smaller rocks at the top of your hillside and some larger ones nearer the bottom. Keep in mind things look smaller at a distance. This goes for lengths of stalks of grass, too! Speaking of grasses—your rocks probably look like they are floating on top of the land rather than nestled into it. You can remedy this by

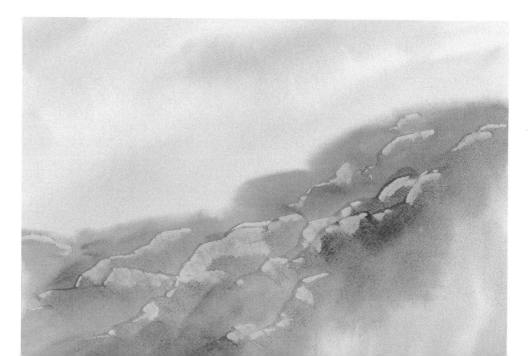

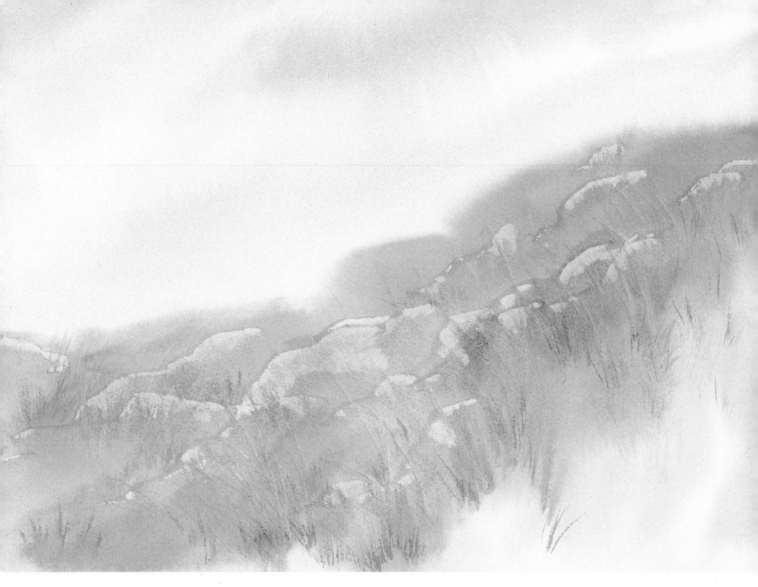

growing some grasses out of the puddles of paint left at the base of your rocks. This can be done by squeezing all water out of the brush, smushing and twisting it in your hand until it looks totally dishevelled, and then flick upward, letting the flicks tumble over one another the way grasses do.

Stand back now, you are almost done. If the rocks still look like they are floating, you might need to "anchor" them by adding a *touch* of brown to the base of them and flicking some grasses out of the wet paint. You can also add a few long accent grasses in the foreground (near the bottom), if you think you need it.

Here you see what a little "grounding" and a few accent pieces of grass can do for sparking up and pulling together a painting. I have used my darkest dark, in this case the brown tone, to lead the eye around the painting. This is important, as the viewer should not "get stuck" in one section. The elements of composition, in this case, color patches, placement of rocks and the direction of the waving grasses, give direction and focus to the painting.

5

Painting — sky, grasses, rocks and splatter

The skills you learned in the preceding chapter lay the groundwork for your next painting. In this exercise we will utilize the ground, sky and grass techniques and add some trees and splatter texture that will result in a painting that will have more to it in terms of composition. In addition, you will add to your range of skills as a watercolorist. With the exception of the first chapter, when everything seemed unfamiliar, in each succeeding section you will use techniques with which you are already comfortable. And as we go along we'll add new procedures. You probably notice that even now, putting a brushload of paint onto a wet empty paper no longer strikes terror to your heart, and an unruly dribble is no longer a menace, but a challenge.

Here we will be painting trees with a sponge, and using splatter. Turn to the Specific Techniques Chapter 11, page 97, and learn how to do this technique before you start to follow the demonstration.

Now, with that somewhat lengthy introduction, you are ready to begin the actual painting.

You need:
 One quarter sheet 140 lb. cold press, edges taped
 and clipped to a board
 1-inch aquarelle brush
 Pieces of natural sponge
 Palette
 Test paper
 Blotting towel or sponge
 Roll of waxed paper

Colors

Raw sienna or yellow ochre
Warm sepia or burnt umber or any dark brown
Cadmium orange
Antwerp or Winsor blue

We will start this painting, like the others, with a thoroughly wet paper and your colors all squeezed out and ready to use. This time we'll make the sky a hazy gold color. To achieve this, mix some raw sienna and a little warm sepia or other brown into a puddle on your palette. It should be a light value.

Too yellow　　　　*Just right*　　　　*Too brown*

On a thoroughly wet paper, make several broad horizontal strokes starting below the middle of the left-hand side of the paper and going diagonally upward, leaving some irregular white spaces between the strokes.

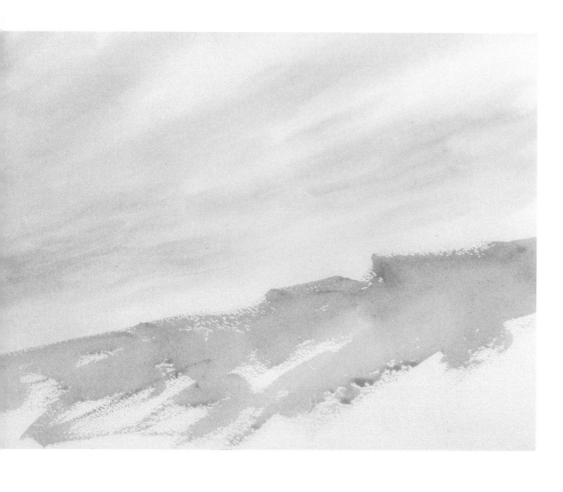

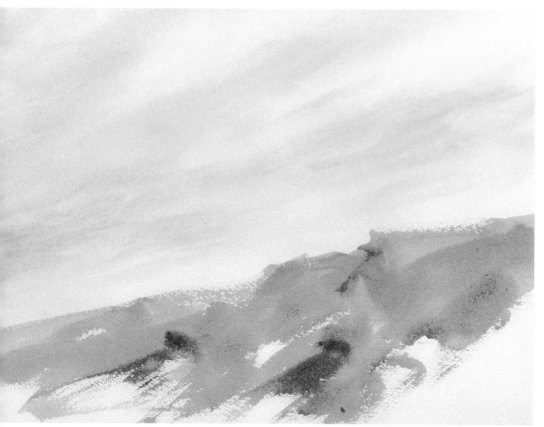

While the paper is still wet, strengthen the gold color on your palette, the one you used for the sky, by picking up more raw sienna. Start above the middle of the right-hand side of the paper and work a gently irregular area downward across your paper, touching the bottom in some, not all, places. This is your light pattern.

Add a darker pattern into your hillside by mixing a *little* more warm sepia or dark brown into the yellow puddle and just a touch of blue. We want to keep this painting in fall tones, so not too much blue. The grass on this hillside is dried and the earth dusty.

Your medium value has just a hint of green by adding the blue. Work that color into pleasing shapes across and down your light pattern, remembering to keep some white areas at the bottom.

Finally, add still more warm sepia to your "land" color and work some good dark areas close to the bottom, always remembering to vary your shapes and your spaces. Leave some white near the bottom. If you left some white in the land areas, that's okay, because white areas planned or unplanned can add interest and sparkle to a watercolor. Don't worry about patching it up. Leave it; we can always "doctor" it up later, if necessary.

While your painting is still wet (and it should still be wet), flick grasses here and there with the "smushed brush" to soften the edges and blend your different areas a little. Just a few tiny flicks in the background and bigger ones nearer the viewer are all that is needed. Also, you might put in a few rocks. Keep in mind that "variety is the spice of rocks:" large, medium and small, connected in small groups. Not too many because our tree will be the focus of this painting, not the rocks.

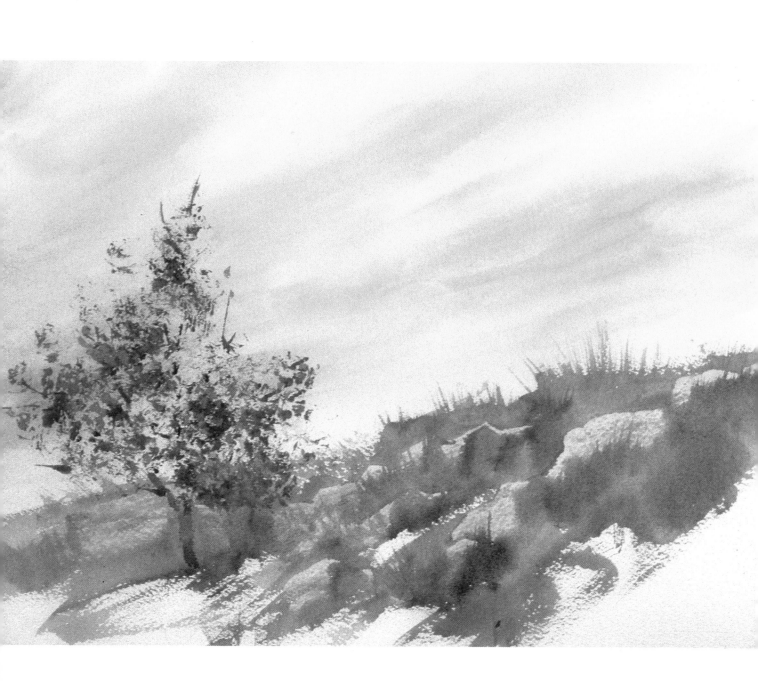

The next step is where to put the tree. The one place it is best not to put the tree is in the middle of the picture space. It will make your design too static. That is to say, if all the action of a painting takes place in the middle, the surrounding areas tend to be even and uniform in size and shape. This, you'll learn, usually makes an uninteresting composition. The easiest way to decide where to put a tree or trees (or anything else, for that matter) is to try it out using a piece of scrap paper. Cut it out the shape of the form you want and move it around your dry painting until it looks right. When you find a spot, mark a few dots with a soft pencil to indicate where it is going to go. Don't trace it; you will be tempted to fill the space exactly and the painting could lose its spontaneity. This idea of trying out the position of something with a paper cut-out can be a helpful procedure. I have solved many compositional problems with it. It's easy to move a paper cutout, but not as easy to move something you have already painted.

As you position your tree, consider the movement of the sky and the movement of the land and rocks. The tree should complete or complement the visual movement you have already started. When you have decided where to put it, use a value that will stand out. For this exercise start your sponge marks with pure, raw sienna, and then pat over them with a little dark brown.

When that has dried, clean out your sponge and make a few patches of cadmium orange—fall colors! Remember to leave spaces between the leaves and to keep your leaf masses interesting and varied. When the orange dries, add your trunk and branches in a color and value that is as intense as the most intense color in your leaf patterns.

Step back from your painting. Does your tree appear to be floating? If it does, drop a little dark color at the base of it and brush a few grasses up around the base of the trunk. You may even scratch in a rock or two.

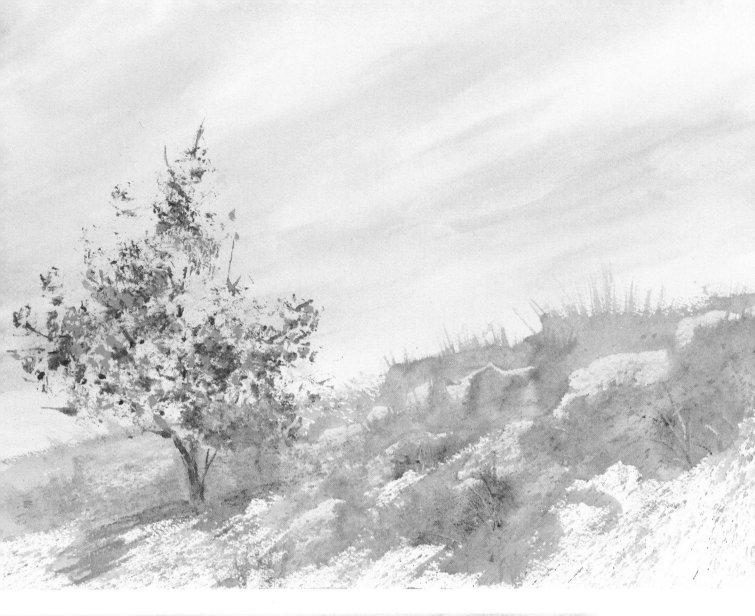

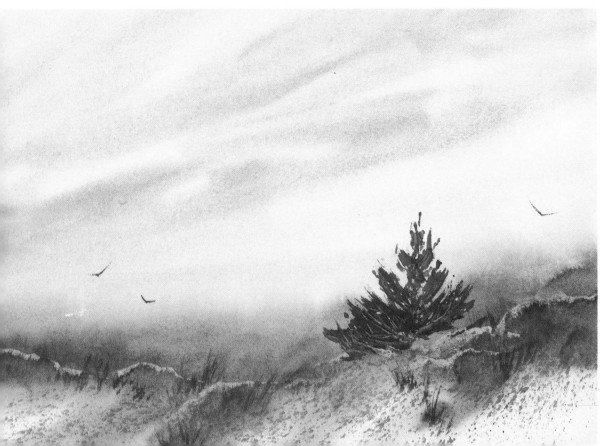

The final touch to this painting will be some splatter. Cover the sky area of your painting with a piece of waxed paper. This will protect your sky from unplanned splatter. Start with light brown and drop some splatter on the hillside (right over the tree) in the direction of the flow of the landscape. If any are too big, blot them with your tissue at once. After your first splatter has dried, do it again with a darker value (add brown and a little blue to your mixture). Make sure some of your splatter lands in the white areas at the bottom. Look at your painting. Does it need more splatter or texture? If so, do it. After this dries, clean your brush and add a couple of large splatters of pure cadmium orange. This will unite your tree with your landscape and tie your painting together. Many artists feel that colors should not be isolated in painting.

Stand back from your painting. Look at it. Adjust areas if you need to. Add a bird(s) if you think they are appropriate. You are done.

Should you want a challenge, do the same painting using only burnt sienna and ultramarine blue and use an evergreen instead of the deciduous tree.

You can do any of these exercises using alternate colors. In fact, you should try it. You might find color combinations that have more appeal for you.

In the small painting, on page 48, I followed the same steps as in the earlier one, except that I used burnt sienna and French ultramarine blue. The sky is a light value of more blue than rust (your burnt sienna), and the land areas are variations of rust and blue in differing values and intensities. I felt that I needed a few rocks to make the composition interesting, and to add some definition to the foreground. A few grasses growing at the bottom of the rocks kept them from floating away. After adding the tree and the directional splatter, I looked at it and decided that it needed a few birds to complete the feeling of a windswept and lonely autumn afternoon on the coast of Maine...or wherever your memory pictures lead you.

Painting — dunes, grasses, water, clouds and splatter

You need:

 11 x 15 inch sheet of Arches 140 lb. cold press, taped and
 clipped to board
 1-inch aquarelle brush
 Clean water—two containers
 A piece of cardboard with a 15-inch straight edge
 Blotting towel or a sponge
 Toilet paper
 Palette
 Test paper

 Colors
 Raw sienna or yellow ochre; Antwerp, Winsor or Prussian
 blue; warm sepia or dark brown; a purple (or you can mix
 some alizarin crimson and blue).

Wet your paper thoroughly (tilt it into the light and check for
dry spots) and wipe up the edges with your tissue paper. Mix up a
pool of blue with a little brown just to soften it somewhat and
apply a *graded wash* sky.

Begin by loading a large brush with the blue, and with your
paper lying flat, start at the top, just at the tape, and bring your
brush *all* the way across the paper in one straight, even stroke.
Without picking up any more color, continue pulling your brush
back and forth until you have run out of color. Let the paint settle
for a minute or so, and while it is shiny, take some loosely crum-
pled toilet paper and gently roll it around the blue area of your

paper. Roll it or pat it, but pick up some of the blue color in nice *irregular* shapes (remember the rock lesson: large, medium, and small; some connected, some separate). If you are unsure about cumulus cloud shapes (those are the big puffy ones), go out and look at them before you begin. Should you get a bit of tissue stuck in your sky, leave it there until your sky is completely dry. Nothing will happen and you will be able to brush it away. If you go after it now, you'll get big messy fingerprints in your sky and have to spend time repairing it later on. Leave it alone!

Work quickly, because the painting needs to be wet. If it has dried, wait until it is *completely* dry and then re-wet it to continue.

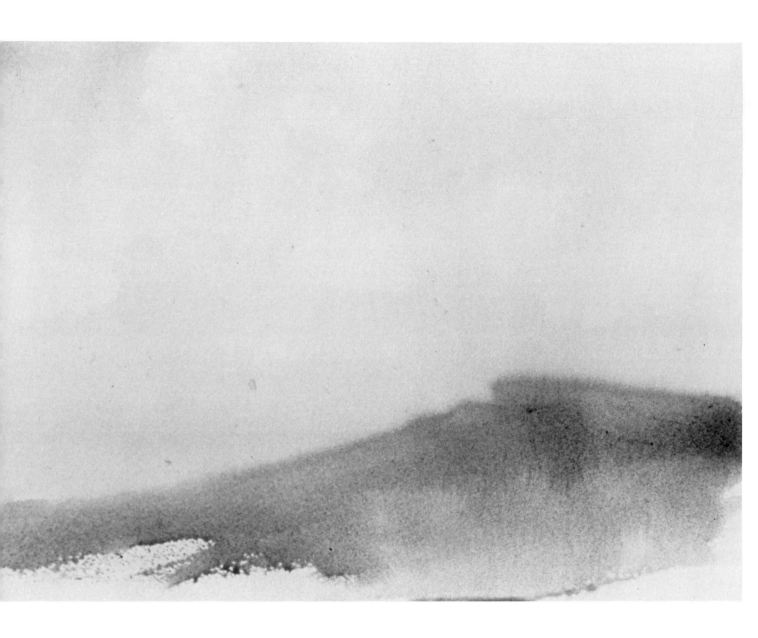

Clean your brush. Now mix some raw sienna or yellow ochre, with a touch of purple (its complement), and sweep on a dune shape. Dunes are long and undulating, not unlike the waves they live near. Carry your shape, high on one side and low on the other side, smoothly all the way across. With long broad strokes, carry more color down from the top of the dune into the foreground, leaving some white areas at the bottom. Make your brush strokes go with the flow of the dune, not in opposition to it.

Quickly clean your brush and mix a gray-green color (raw sienna, a little blue, and a touch of brown). While your dune and sky are still wet, wash some green areas on the top of your dune, and here and there on the dune as it goes across your page. Try to cre-

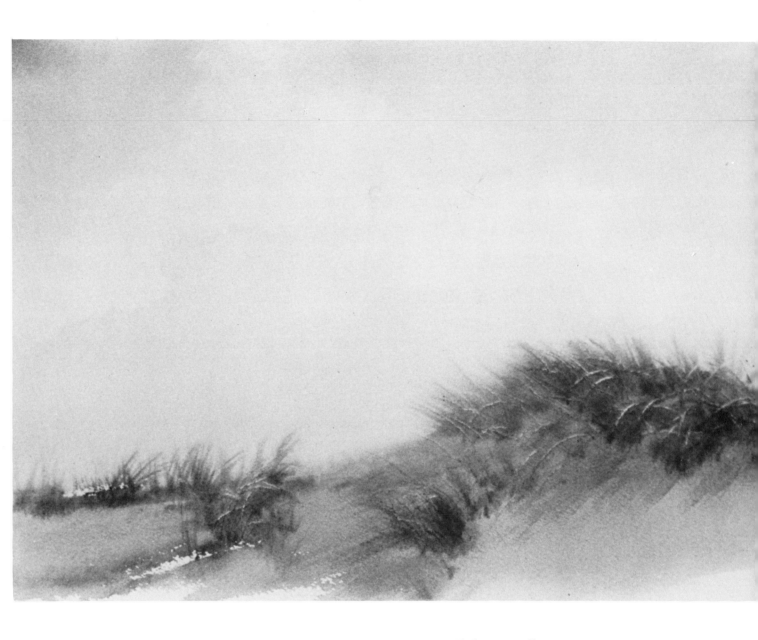

ate some interesting looking shapes as you do this. While it is still wet, use the damp-smushed brush grass technique to make your dune grasses grow in *one* direction to suggest a sea breeze. Next, add a few accent grasses tumbling over one another and curling off the top of the dune, by scratching them in with your fingernails or the end of your brush handle.

If this looks satisfactory to you, let it dry *completely* before you proceed. If it needs a little help here or there in terms of value or arrangement of shapes—more grass, another dune shape, a cloud that needs to be re-blotted—you can do it at this stage. But remember: it's better to wait if you are in doubt. You can always fix it up later.

Now for the water/horizon line. Making sure your painting is *completely* dry, pick a spot where you would like your horizon line to be. It can be anywhere, but try to avoid placing it in the middle of the paper. Also, pick a spot that will allow the horizon line to stop *before* or *after* the midpoint of your picture. Again, it is just a matter of trying to keep important areas off center. It may help to use a piece of cardboard with a long straight edge to help you pick a good position for the horizon. Move it around until you find the right place.

Now, load up your clean brush with a blue that is a little darker and stronger than your sky color, using the same colors you did for your sky. So you can establish a relatively straight horizon line, hold your long, straight edge cardboard at a 45-degree angle to your painting, low near the bottom and about 2 to 3 inches above where you want your horizon line to fall. Place the tip of your loaded brush at that horizon line, with the ferrule or shaft of your brush resting against the straight edge of your cardboard. Hold the cardboard securely with your non-painting hand. See above illustration.

Now, draw the brush across the paper and along the edge of the cardboard, starting at the side margin tape. Do this quickly and firmly and let your paintline from the brush bump right into your dune. You will blot it in a minute. Put the cardboard aside with the remaining paint on the brush (don't pick up any more!), fill in the rest of your water area using straight, horizontal strokes.

When painting water, use mainly horizontal strokes. You never see waves at the horizon even on the stormiest days. You only see the waves up close. If you paint water in anything but a horizontal

manner, your water won't look flat and will appear to "stand up."

If your brush skips a little, and leaves little spots of white, *leave them*! This is to be desired because it will make your water sparkle. Quickly blot with your tissue the areas of dune or grass where you have overlapped with your water stroke. Now, *don't play in it*. If your brush skipped a little on the horizon, leave it. You won't see it from the proper viewing distance of 5 to 10 feet! If you touch it now, you may get bubbles where you don't want them.

When *dry*, look at your painting. Does it need splatter? Is there a place that can use some texture? There should be because I have planned it that way.

Cover any areas you don't want splattered with wax paper. Incidentally, I use wax paper rather than something opaque such as a paper towel because it is transparent and you can see the progress of your whole painting as you splatter. You don't want splatter in the water area, so you might have to tear or cut a piece of waxed paper to fix the contours of your particular composition.

Mix a light value of the colors you have been using, mostly a brownish-gold, and drop fine, light splatter in the direction of the flow of your dune. Always test splatter on a piece of scrap paper before you actually do it on your painting.

When the first layer of splatter is dry, add another layer of slightly darker, larger (more water in brush) splatter over the first layer, with the tails leading in the same direction. Remove your waxed paper and look at the whole picture. Determine if you need more splatter or if your composition calls for a bird or a flock of birds soaring above the dune. If you need birds, refer to Chapter 3 for a "bird refresher course" before you add them. Keep in mind the need for variety in size, direction of movement, and placement.

Your finished painting should have all of these elements in it, in your own arrangement. If you'd like to try it again and suggest a storm, use only warm sepia, Antwerp blue (or any cold blue), and raw sienna. You can achieve a beautiful stormy gray with warm sepia and Antwerp or pthalo blue. Make your grasses blow even more strongly and make your sky dark and threatening.

You can also try a sunrise or sunset...you can try anything.

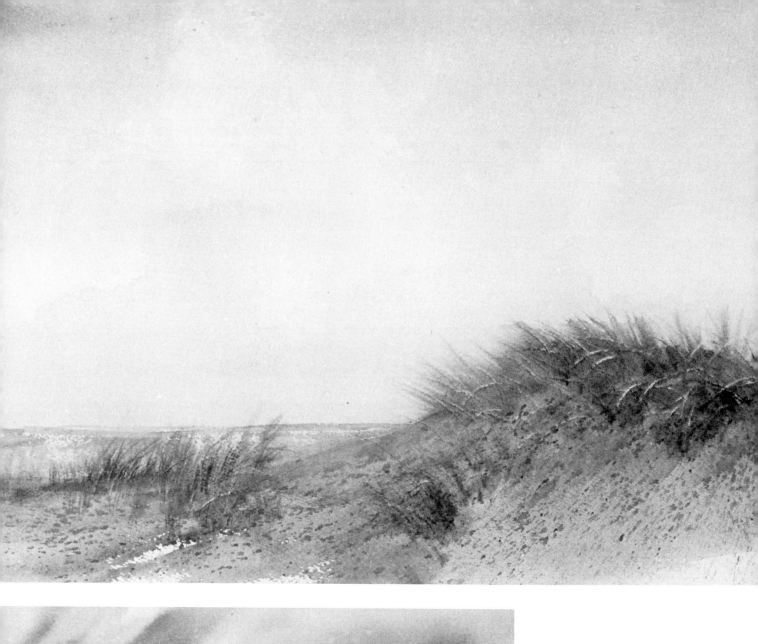
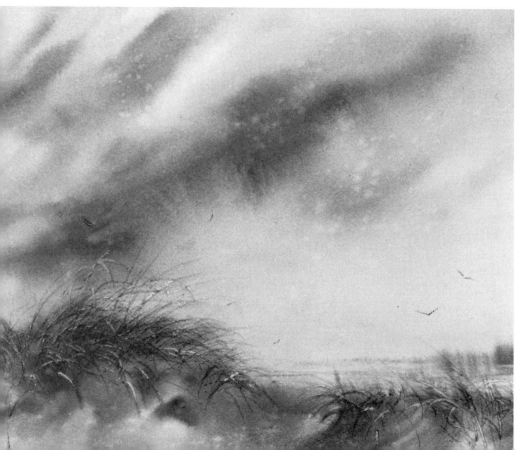

Painting — dunes, grasses dunefence/boardwalk

To use what I call the dune fence (snow fence) or boardwalk technique requires a little practice before you start your painting. This was true in the case of the tree and splatter techniques, and it's a good idea to practice your skills whenever and as often as you can. In other words, don't try to make a painting and learn a new technique at the same time, take it in stages. You will be more confident and therefore more successful.

To start the dune fence, load up your brush with any color of medium value (use leftover paint on your palette) and blot it lightly on your towel or damp sponge so that your brush is wet but not dripping. Hold your brush horizontally (parallel to the bottom of the paper) and touch the straight edge of the brush to the paper so that it makes a vertical line. (If it makes a curved line, straighten the bristles out with your fingers.) Repeat this action, touching the whole edge of the brush at tiny intervals in a straight path across your practice paper. See above illustration .

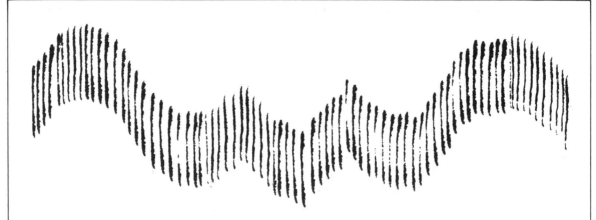

Once you can get a straight, even, "unblobby" line, try an undulating line. After all, dune and snow fences follow the contours of the land. Because these fences have a tendency to flop and fall over, you need to learn to create that illusion. Make some fence marks by pivoting your brush on one end.

Now you are ready to do a whole fence. Sketch a dune or hill form, either with pencil or paint (let the paint *dry* if you use paint). Follow that form with a fence. Let it tumble and maybe hide behind one section of the hill.

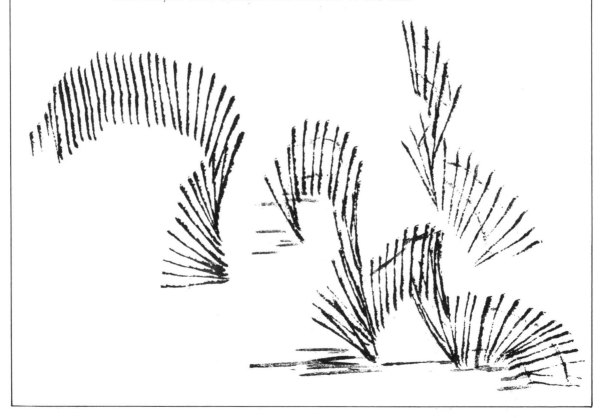

Since a painting is never more than an illusion of reality it is a small step for an artist to turn a dune fence into a boardwalk. After all, as far as visual effects are concerned, a boardwalk is only a flat dune fence. All that's required is that you make horizontal rather than vertical strokes with your brush. When you introduce the pattern into your picture, remember our few words on perspective. Things far away are smaller and less distinct than things close up.

A few upright (vertical) strokes will produce a handrail.

When this feels comfortable, you are ready to make your painting.

You need:
 11 x 15 inch piece of Arches 140 lb. cold press, taped and clipped to a board
 2 containers of clean water
 1-inch aquarelle brush
 Tissues
 Blotting towel or wet sponge
 Waxed paper
 Test paper
 Palette

Colors
 Blue for sky
 Raw sienna or yellow ochre
 Warm sepia or dark brown
 Purple (or mix by using alizarin crimson and
 ultramarine blue)

Wet your paper thoroughly and clean up the water along the edge. Wash in a sky tone using blue softened with either a little brown or, for a more interesting hue, a *little* alizarin crimson. Your sky strokes need not connect, but carry some color at least two-thirds of the way down the paper. You may elect to add clouds or not; that is your choice. As we did in the previous chapter, sweep in a dune form using a moderately intense mixture of raw sienna touched with a bit of alizarin crimson (a very strong color) and another whisker of blue. You may leave some white areas at the bottom. With the remaining paint on the brush, sweep in a horizontal line somewhat below the middle of your paper all the way across to your dune line. The paint will blur and fuzz; you want it to, as you are suggesting a land mass. Because you have used up most of the paint on your brush, the color should be less intense than your foreground.

While your paint is still wet, mix a green tone using raw sienna and blue. Put some grass shapes on and across the dune in the foreground. Don't try to draw the grass forms. The water on the paper will take care of fuzzing the edges and making them look more "grassy" than we ever could!

With the remaining green paint on your brush, paint in some smaller areas along the top of your background land mass.

You may add a few "smushed brush" grasses, and a few tumbled, scratched grasses made with your fingernails or the end of the brush handle in your *foreground* for accent and interest. Don't make the scratched grasses *too big*. It's okay to brush your grasses up and over part of your background land mass.

Let your painting dry *completely* at this point. While it is drying, you can be looking at it and deciding where you might like to place your dune fence. You might even practice your dune fences again on a piece of scrap paper.

When your painting is dry, mix a middle value using a mixture of colors you have already used in your painting. A middle value will be about halfway between your lightest light value and your darkest dark. If your fence is too light it won't show, and if it is too dark you will make it look too important.

Start your fence somewhere along the dune. Let it drop down behind the dune somewhat, and then curve around to the foreground. End your fence anywhere, but again try to avoid the *dead center* of your painting. You may want to make more or less fence somewhere else on your painting. Just remember to be varied in whatever you do.

Your painting is almost done. Look at it. Check the values (the lights and darks). Should you grow a few grasses around the base of your fence? If the fence is too dark, wait until it is completely dry and then wet the fence with clean water and blot it immediately with clean tissue paper. Repeat until your fence is light enough. If it is too light, you can re-apply it with a *slightly* darker value. Once you have corrected this much, you have to decide if there is anything else you might need. Would birds help? A few people? Refer to the section on specific techniques to learn "people strokes" (see page 108) and add a few if they will help the composition—but only if they will. Remember, you may have a perfectly good painting right now. Don't *overdo* it. If you have any question at all, wait, look at it in the mirror, or even cut a few people shapes out of paper and lay them on your dry painting to help you decide. Using paper shapes lets you change your mind without making a permanent disaster.

Here is my finished painting. Yours may or may not have people and/or birds. It is your painting. You might like to try it again using different colors. Good combinations to try are burnt sienna and ultramarine blue for a gray stormy effect, or raw sienna, warm sepia and green for a hot, hazy summer effect.

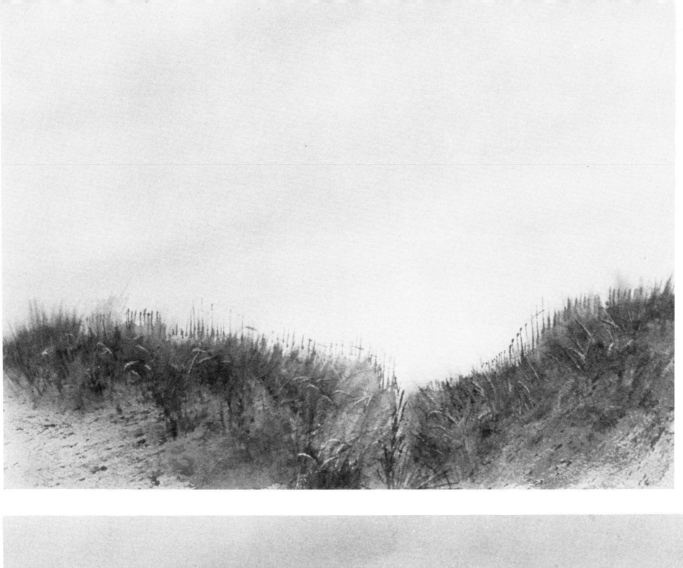

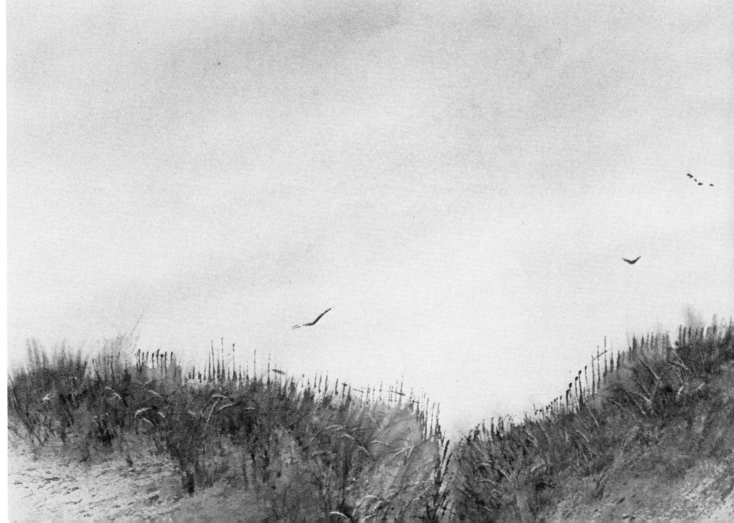

Painting — Painted rocks, grasses, pine trees and splatter

Before starting this painting, refer to the specific techniques chapter and review how to make pine trees with a sponge or a brush, and practice a few before you start the painting.

You need:
 One quarter sheet of Arches 140 lb. cold press, taped
 Water
 1-inch aquarelle
 Soft pencil #1 or #2
 Sponge
 Palette
 Kneaded rubber eraser
 Credit card
 Test paper
 Wax paper
 Tissue
 12-inch piece of cardboard with a straight edge

 Colors
 Burnt sienna, ultramarine blue, possibly some cadmium
 yellow

Along many sea coasts you are likely to find rocky promontories jutting down to the ocean with pine trees near the water's edge. Such simple shapes make fine subjects for watercolors. Let's try one now.

To start this time, we are going to do a little drawing—just a few lines to help you remember contours. With your pencil draw a light, loosely jagged line starting about 2 inches below the middle of your paper and carry it down to the bottom, about two inches up from the left-hand side. I have made my line rather dark so you can see what I am doing. Make yours just barely visible.

Rocks, as you know, can be huge, massive and *irregular*. In this case, don't make a picket fence line. Also, don't *erase* all over your paper. You may choose to erase your pencil lines after your completed painting is dry, but not all artists do. Many leave them on the papers. Either way is acceptable.

Wet your paper down to your rock line only. Pour off the excess and with your ultramarine and a wee bit of burnt sienna drop in a sky pattern, either a graded wash or streaks of color that you will let run. Lift your paper and tilt it toward you so the water and color are running down toward you. Now tilt it to one side (right or left) and the extra water will collect in a puddle just above the dry area. Blot it with your tissue or lift it off with a squeezed out brush. Notice how the water stays above your pencil line. This is handy when you are painting a sky around a house or other object. The sky colors will probably run and blend a bit, making a sort of windswept appearance. If you were overly generous in your water application and a drip occurs through your rock area, don't worry about it. Lay your paper down and blot it with tissue. Don't try to scrub it out. We are going to paint rocks over it anyway. Let it dry completely.

Now you are ready to paint your rocks. This is a different technique than scraping them out with a credit card. You might practice a few before starting on your painting. It's a good thing to do while waiting for your sky to dry.

Mix some burnt sienna, add a little blue until you get a brownish gray tone.

Holding your brush so you get the widest possible stroke and making sure that your paper is totally dry, follow but not too carefully, your pencil line across the picture. Because you are working on dry paper, your brush will skip a little. That's okay; it's supposed to. It will give your rocks sparkle and highlights. Now make a few broad strokes that are diagonally downward, keeping in mind how rocks "grow." Leave some white areas; they will be highlights later.

While your rock forms are still wet, think for a moment where the light source (the sun) is coming from. Drop in some darker areas on the underside and on the sides opposite the light on the rock forms. Mix a cooler, stronger color for this—use more blue than burnt sienna.

Now, while it is still wet, press the palm of your hand or the side of your fist into the wet areas and you'll get a pleasing texture that manages to look rather like rocks from a few feet away. It may help to add a few smushed brush grasses at the bases of some of your rocks.

You can go to work now on your pine trees. The rocks need not be totally dry. (Practice a few first.) You can cut out a few of your practice trees and move them around your composition to see where they'll fit best. Once you have made your decision it's time

to put them in. Use a color that's bluer than your rock shadow value (and you might try adding a little cadmium yellow or New Gamboge; I prefer the latter if you have it), to make your tone a dark blue-green.

Actually, any strong blue/green/gray will do. Put in your branches starting at the bottom and work your way upwards to the smaller ones. Work for variety and keep them airy so light and "birds" can pass through. *Variety* is needed both in branch size and in tree size. Twins and triplets are exciting in families, but they are dull in landscapes.

After you put in the first branches, scrape a jagged trunk *upward* and *outward* from the bottom. Then let the trees dry. Add a few branches *over parts* of the trunk. We never see a whole pine tree trunk from bottom to top unless the tree is dead!

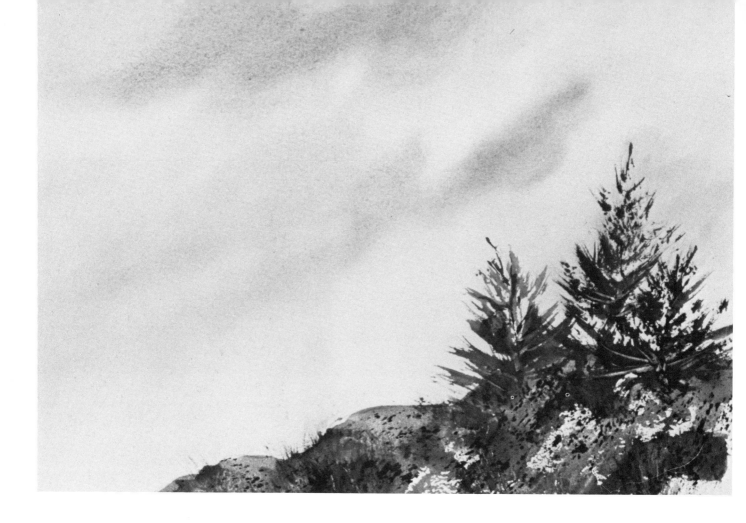

You will need some more texture on your rocks and into your white areas (you did leave some, didn't you?) at the bottom. This we will do with our old friend "splatter!" Cover up the whole sky area with waxed paper leaving only the rock area exposed. Start with a light value, not too wet, and splatter in the direction of the flow of the rocks starting in the top of the rock area and moving down to the bottom and into the white areas. If some of the drops are too big in the rocks, smudge them with your palm or fist to give them an interesting texture. When the splatter dries, apply some darker splatter in the same direction. Sometimes, if an area looks too light, you can adjust it with splatter. Remember to test it first on scrap paper. Splatter is a technique that allows you to make 1000 mistakes at once. Be careful.

If you do get an unplanned splat, blot it at once with your tissue and you probably won't even see it!

Check your composition and your values now. Do your trees look like they are floating? They may need to be grounded by adding some dark wispy grasses to their base or bases. If some splatter looks too big and too dark, you can wipe it out by wetting it after it is dry, then blotting it.

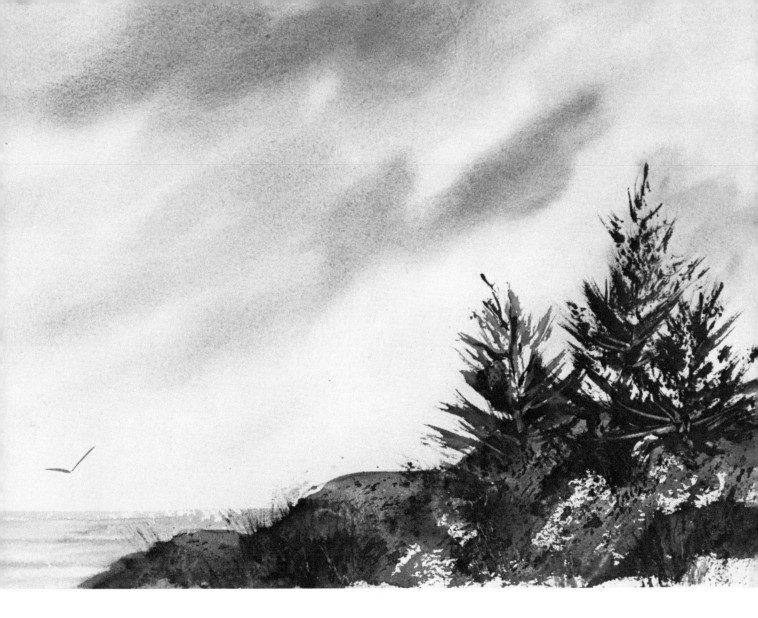

You may decide your painting is done now. It might well be.
But if you need "a little more action," you can add birds, a piling
or two, people, and/or a water line. But, please, not all of these. Be
selective! If you add a water line, it will give your painting depth.
Remember how we did it in chapter six? If you don't, review it.
Make *one stroke* across the horizon. Use a sky color that is just a
little more intense. Also remember that your water will sparkle if
the brush skips across your dry paper.

If your line is slanted or doesn't connect, *don't try to correct it
until it has dried*. It'll be much easier to fix then. If you work into it
when it's wet, or even semi-wet, you may create a blobby mess.

When dry, pull the tape from your finished painting and look
at it from across the room. Study it. If it needs a *little* touch here or
there, do it. If you are not sure, leave it alone. If it needs a whole
lot, start a new picture on the back.

Painting — Building, grasses, trees and hillside

As in the previous chapter, this painting will involve some drawing, a little more than last time but still fairly elementary. If you feel nervous about the drawing, *trace* the picture of the house in the illustration and transfer it to your paper. It is shown at the size it should be for your composition.

You need:
> One quarter sheet Arches 140 lb. cold press, taped
> Clean water
> 1-inch aquarelle brush, and your round brush or a rigger
> brush would be helpful
> Drawing pencil
> Kneaded rubber eraser
> Palette
> Waxed paper
> Test paper
> Sponge
> Tissue paper
> Razor blade or credit card

> Colors
> Antwerp, Prussian or pthalo blue
> Raw sienna
> Cadmium yellow
> Warm sepia or dark brown
> Olive green or Hooker's green light

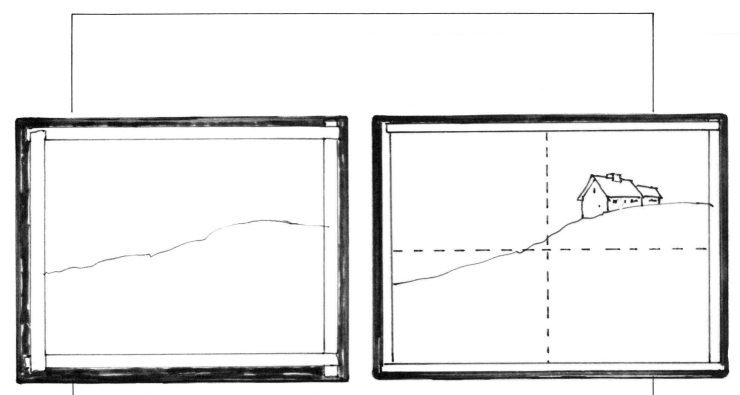

Start by making an irregular hillside line and putting this house or a house or barn of your choosing in place—any place along the line except *the middle!* Once again I am making my lines rather dark so you can see them; make your lines lighter.

This is a simple house form to use. Note how uncomplicated the windows and doors are suggested. A house seen from a distance doesn't show *much* detail. Mainly there are just some light and dark shapes and a few lines that distinguish the silhouette.

This time we will start by painting the house. Mix a *light* value of your blue and brown.

Using that color, paint everything on the house except the roof and chimney. Since I plan to have the light coming in from the upper left in this painting, the sides of the house and roof that are angled in that direction will be the lightest. The roof overhang will, however, cast shadows. So, as the lightest value is drying, mix a somewhat darker value of the same two colors and with the flat/skinny edge of your brush, touch that dark value right below the roof line. Voila! Cast shadows!

You may also touch in the areas where the windows and doors are going to be *on the light side* while your light value is still damp. The paint will fuzz a little and give the impression of window and door shapes as seen from a distance. Don't fuss with it, and don't get too detailed. You cannot see a nail hole or a peeling clapboard at 100 feet!

Let this dry completely. Mix the same two colors in a darker value but still gray. Paint the sides of your house that are away from the sun. Just a touch with the skinny side of your brush (like the dune fence touch) will suggest windows. To paint the chimney (remember your light and dark side must agree with the rest of the house), take a *very light* value of burnt sienna and paint the side of the chimney facing the sun. Mix a darker shade, add a touch of blue to it and paint the dark side. It's okay to let the edges touch and blur a bit. When the chimney dries, you can cast its shadow using one quick brush stroke in the same gray used on the dark side of the house.

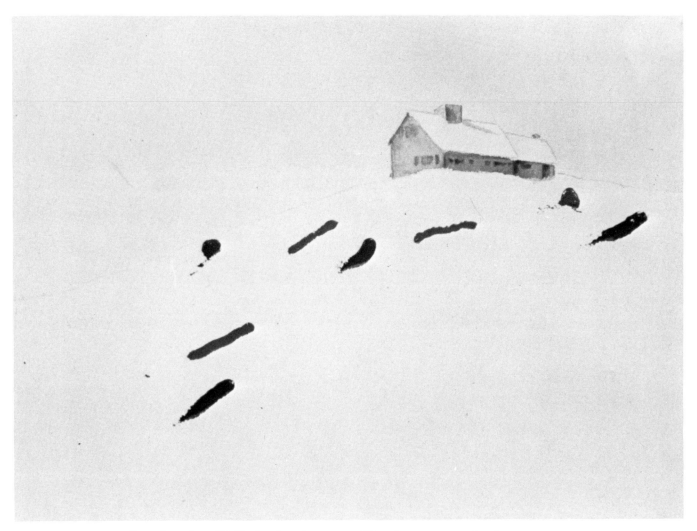

Let this dry. We'll do the sky next. Wet the paper with clean water all around the house, going right up to the edges then down to the hillside line. Mix a medium value of Antwerp blue with a little brown and make some directional streaks across the sky. Try to leave some white areas. Lift your paper and tilt it toward you as you did in your rocks and pine tree painting. Then tilt it to one side so you get an interesting sky with some movement to it. If there are any drips or puddles at the edge pick them up with your tissue or a damp, squeezed-out brush. Let this dry.

To do our foreground we are going to do something different than we have done before. We'll squeeze paint from the tube directly onto the dry foreground area and then use clear water to suggest the land patterns. Squirt a few (two or three) small ¼-inch blobs of raw sienna or yellow ochre across the top of your hill line and add two more somewhere in your foreground. Now put one ¼-inch blob of olive green or Hooker's green light, up on the top with your yellow blobs and put two or three more down below.

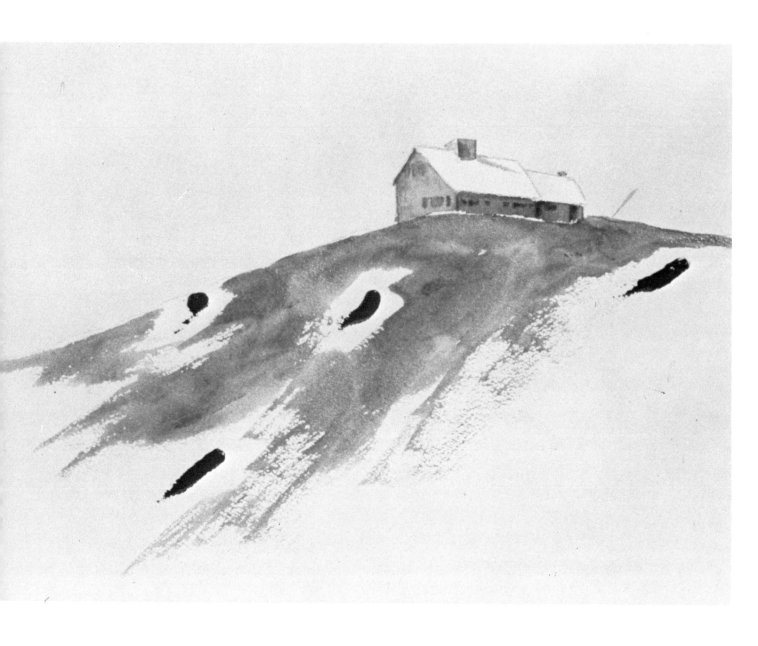

With a brushload of clean water, mix into the yellow paint areas only. Smush and wiggle them irregularly across your hillside. Work the yellow shapes down towards the bottom, but leave some white shapes throughout, particularly towards the bottom. Avoid the green blobs totally. Mix in the yellow color up along the top of your line and along the base of your house. Clean your brush, squeeze it out and smush it against the palm of your hand. Now make some *very small* grass flicks along the top of your hillside line. You want to have a soft edge up there. Remember the grass is distant, so the line should be soft and indistinct.

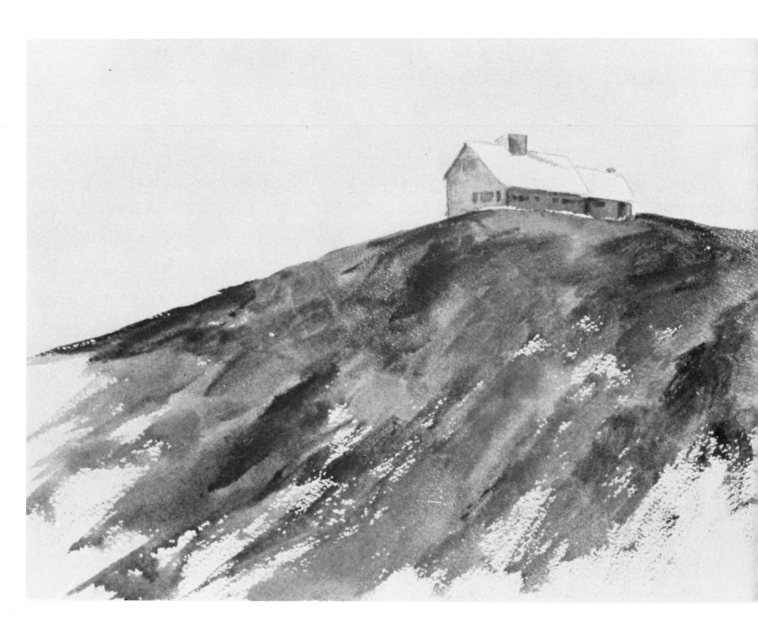

Now, take more clean water and work into the green blobs. Move the green paint around, making a mottled green pattern that interconnects with the yellow pattern, sometimes blending with it, sometimes leaving pure patches of yellow intact. Carry the green shapes down toward the bottom in a pleasing directional pattern, again leaving some irregular white shapes at the bottom. Clean your brush and mash it again, making grass flicks over the entire hillside, particularly where two patches of pure color are next to each other. Carrying green flicks over a yellow area will make it look interesting.

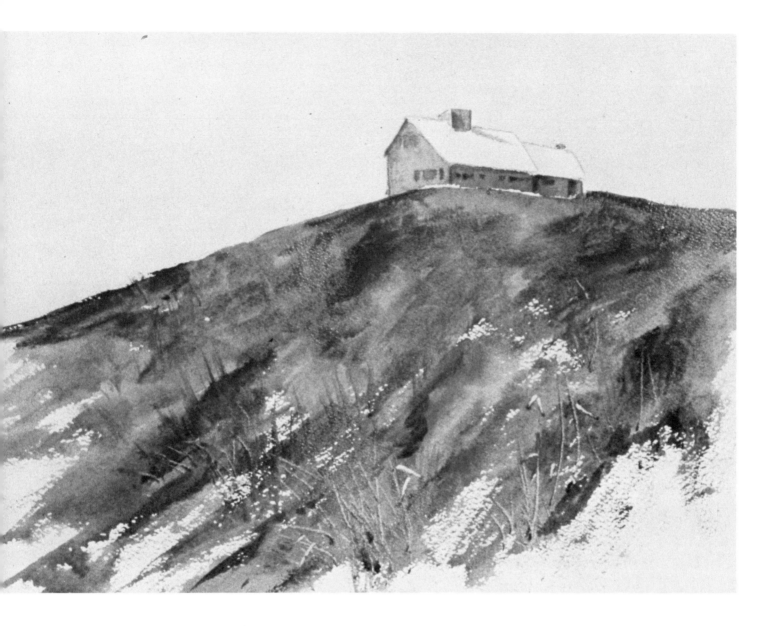

If the paint is too wet, wait a minute or two and then try it. If you want, you can add some scratches for larger grasses in the foreground only, but think about the composition when you do it. Make the direction of your grasses "fit" with the rest of your painting.

You may wish to make a dark pattern by mixing a thick concentration (lots of paint, little water) of your raw sienna or yellow ochre with some raw umber. Use this to add some darks throughout your foreground. Do it if you feel you need it. I did. You also might scratch in some credit card rocks while the paint is still wet. To help the feeling of depth and perspective, it it best to suggest larger rocks in the foreground, smaller ones farther away. Also, for interest, keep them *varied* in size and shape and positioning.

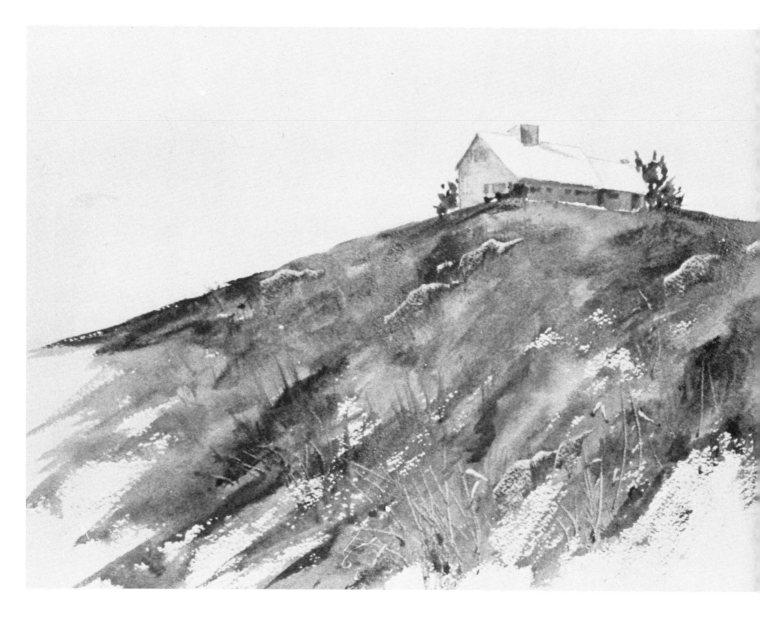

"Grow" some dark grasses at the base of your rocks so they won't
look like they are floating, and also to soften the base areas. When
your foreground looks right, you are ready to add some trees
around your house—or anywhere else you may feel they are needed.

 Review the tree technique in the special techniques section. It
is always a good idea to practice a bit before you begin. A few dark
bushes and trees around your house or barn will soften its silhou-
ette against the sky and make a more harmonious environment. It
will take some care or you may create a "value problem." The
value of the trees should not be as dark as the darkest dark in your
foreground or the trees will appear to leap forward visually. If it
does happen, wait until they dry completely and then lift off a little
color with clean water and a tissue.

Mix a middle value of blue, yellow, and brown, or use your green darkened with a little brown and drop in some tree shapes (always irregular, not balloons) around your house. If you don't want the trees to cover part of the roof, mask the house by holding a piece of paper or cardboard over it while you are dotting with your sponge. If it is appropriate, add a few branches or trunk shapes with your round brush. *Small ones*. The trees are far away. Don't change colors, for at that distance all you will see is value.

A little well-placed splatter will finish things up nicely. It will offer some ground texture and it will give your white spaces in the foreground a pleasant sandy look. Mix a middle value of yellow and brown; cover your sky and house with waxed paper and (after you have tried it on your test paper) splatter lightly in the direction of the flow of your landscape. Carry the splatter down into your white area. Repeat this with your green color, and finally with the green and brown mixed together.

Now take a good look at your painting from across the room. Does it flow? Does it need a little more dark somewhere? Can you do it with splatter? If it needs more light areas there are ways of sparking up an area that has gotten too "heavy or muddy." Wait until your painting is completely dry. You can add sparkle by splatting, scratching with a razor blade or even, in tiny areas, touching it here and there with opaque white paint. For the beginner, scratching out and using opaque white can be risky. It would be better not to try such procedures until you are a little more experienced. In any case, *don't overdo it*. Practice first.

You could try another version of this same scene by working with only blue and brown and making the trees bare. You'll create a spooky, haunting feeling with a totally different mood than your first painting.

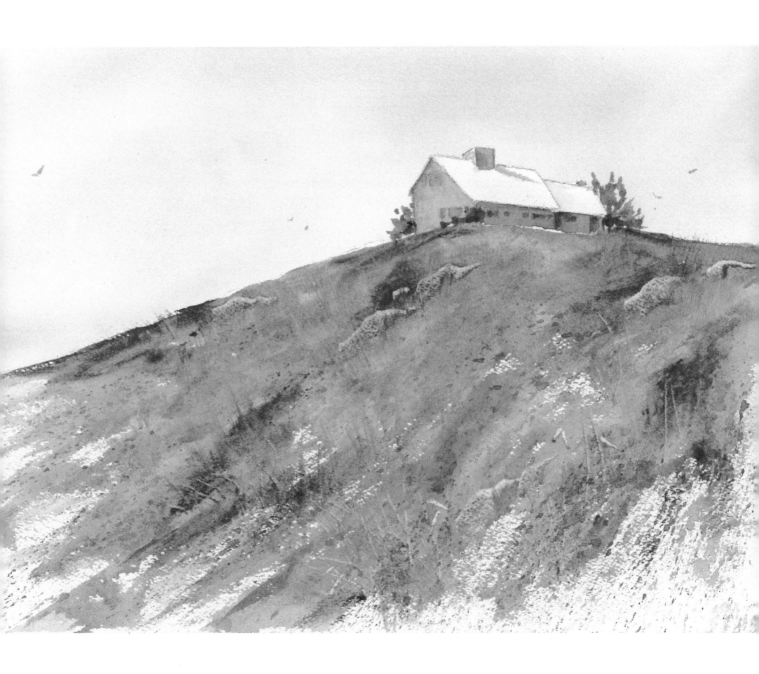

10

Gallery

In this chapter a variety of paintings by a number of artists are presented. These pictures demonstrate many of the techniques that you have learned so far. Here you will see them in different settings. These techniques are useful in landscape painting, but these, and any others that you learn should never be used exclusively. You will run the risk of becoming a "formula painter" and everything you do will look the same. This is different from developing a style, that will develop naturally, and as I have said earlier, you can't push it, so don't try.

Still Shadows

In "Still Shallows," Joan Dunkle has combined underpainting with free-flowing abstract washes (much like our first skies), lift-outs with stencils, over painting, glazing, and splatter with paint, and splatter with clean water into damp paint. She has achieved the illusion of rocks in shallow water, and at the same time she has created a wonderful visual pattern of lights and darks that carry the eye around the composition. Note the negative spaces (spaces between the rock forms). They are the darks that help unify the composition, and at the same time create a feeling of motion.

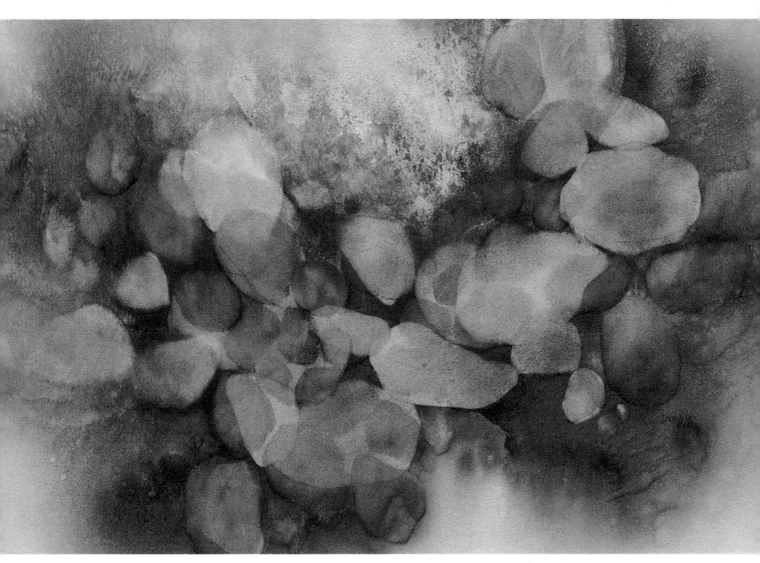

Joan Dunkle

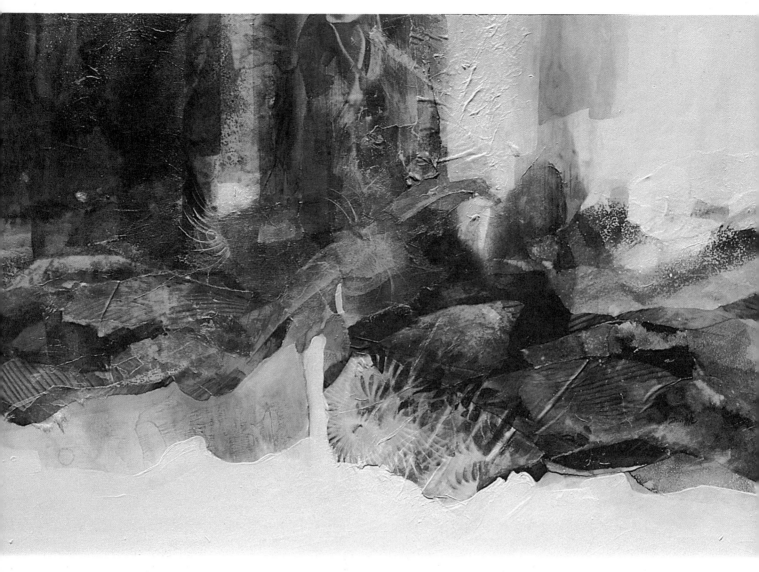

Edge of the Woods **Joan Dunkle**

This is a multi-media painting that suggests the feeling of never ending corridors of tree trunks as seen when standing at the edge of a deep forest. Joan first painted in large blocks of color, then she overlaid these with slightly crumpled rice paper to create an irregular texture. She continued glazing and lifting out until the final effect was achieved.

At first glance, the viewer might see the painting as divided into quarters, but upon closer inspection, you will see that there are no true repetitions of shape, and the long rectangle of light in the upper left-hand dark area, marvelously creates the illusion of depth upon a two-dimensional surface.

Sundial **Priscilla Patrone**

Done on Crescent watercolor board #112, this multi-media painting incorporates rice paper, 2-ply museum board, acrylic paint, gouache (opaque watercolor), transparent watercolor, and Arches 140 lb. cold press paper. The artist has painted, torn and cut, and ultimately pasted this painting together. The result is an exciting abstract comprised of soft and hard edges with a multiplicity of textures.

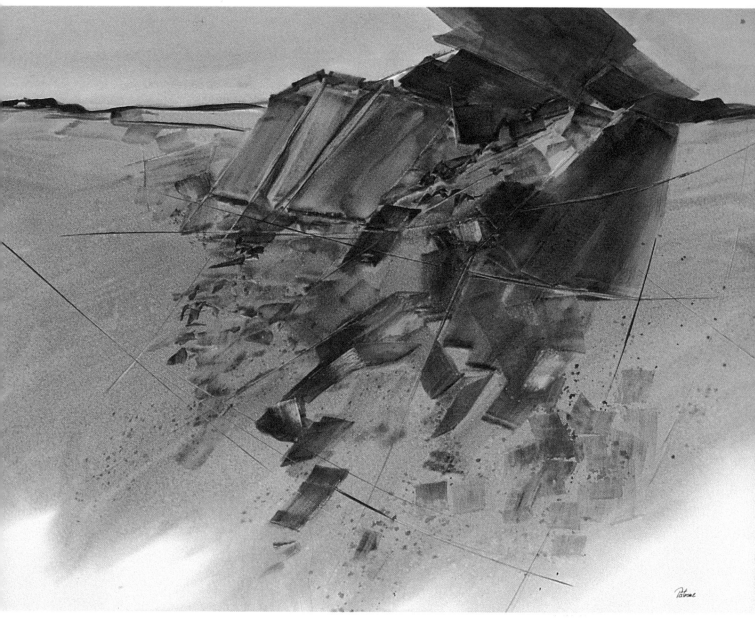

Maine Shore **Priscilla Patrone**

 This painting was done totally in transparent watercolor, and employs washes, credit card scrapings, color lift-outs and splatter. This semi-abstract is a suggestion of the Maine coast; a familiar subject seen with a fresh eye.

 These two paintings represent the wide range of Priscilla Patrone's abilities and interests. She started painting in oils, with a realistic approach. In time she shifted to watercolor, and to images beyond the factual, and into the realm of creative interplay of mood and media.

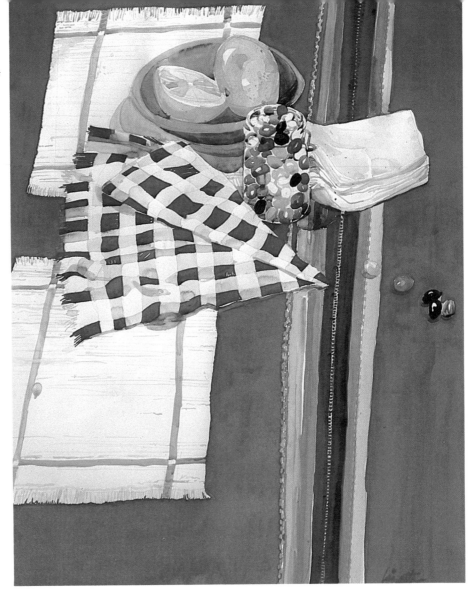

Photo by Roger Bainbridge

Jelly Beans

Mary Lizotte

Mary Lizotte lives, breathes and speaks color. Her paintings virtually dance with it. If you look at the painting not as a table top, but as an arrangement of shape and color, you are immediately struck by the strong abstract pattern underlying the reality. The picture is made up of geometric shapes, the hardness of which is relieved by the dish of lemons and the jelly beans. Note how the folded napkins break up the diagonal influence of the stripe. Without these intrusions, the stripe would carry the viewer's eye down and out of the painting; something we talked about earlier. Here, Mary uses a strong diagonal, but uses it effectively. The same things we say about landscape painting, about composition, shape, line, color and value are just as vital to still life painting and to portraiture. They are also functional components of the pure abstract. They are constants, rules, if you will, and it is handy to know what they are. One may break these rules, but when you do, you should do it knowing exactly what you are doing...and why!

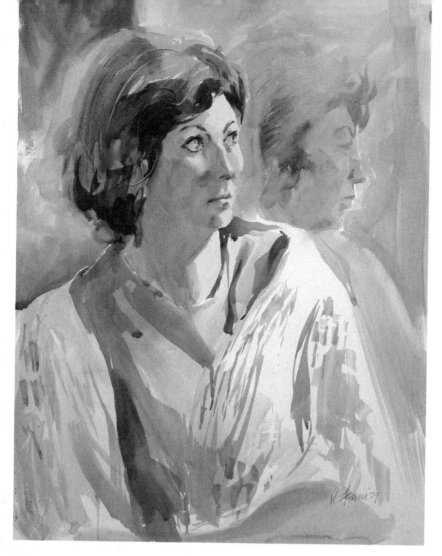

Pat

Ruth Ferrara

Ruth Ferrara is a commercial artist who specializes in fashion illustration for a major department store. When she has the time she paints people. She demonstrates the precision of the illustrator in her ability to capture a likeness, and yet she is able to utilize the free-flowing freshness that watercolor provides.

Note particularly the scratches in the hair. These are the same kind of scratches we used in making grasses. We used them to bring light areas into darker areas, and to add direction. Ruth has done the same. By scratching a couple of wisps of hair into the darker area, she has effectively produced the feeling of a pleasant person who doesn't have every hair in place.

In her portraiture, Ruth draws parallels to still life painting. One is always aware of the light source, cast shadows, shapes, and negative and positive spaces. Therefore, if you were to turn this painting upside-down (something I often do to check my composition), you would clearly see a pleasing arrangement of shapes and values.

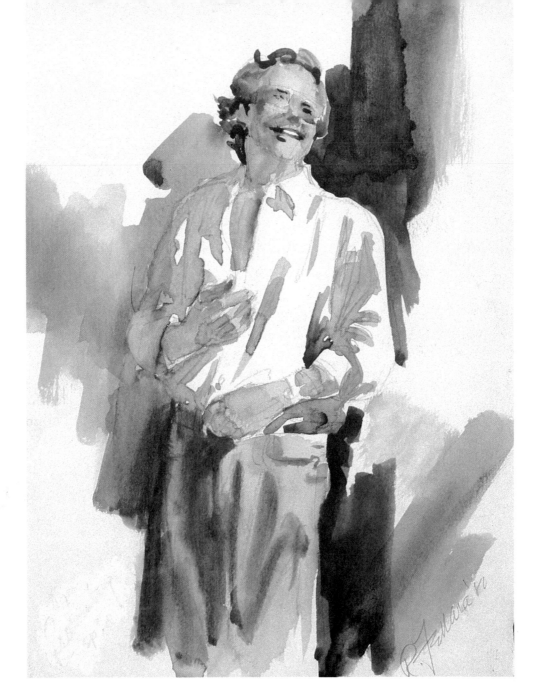

Watercolor Sketch of Rauchenberg **Ruth Ferrara**

When Ruth can't get a live model, she sometimes uses a photograph as a starting point. Here she used a black and white photo from a newspaper. Notice how she has brought the figure in this painting to the foreground by establishing a dark abstract background. The broad strokes, laid down with seeming abandon, add to the feeling of strength and joyousness in the person in the picture. Ruth can say "shadow" and "fold" with just a few strokes of her experienced brush. Too much detail would make this painting lose all the spontaneity that the artist wanted, and the medium allows.

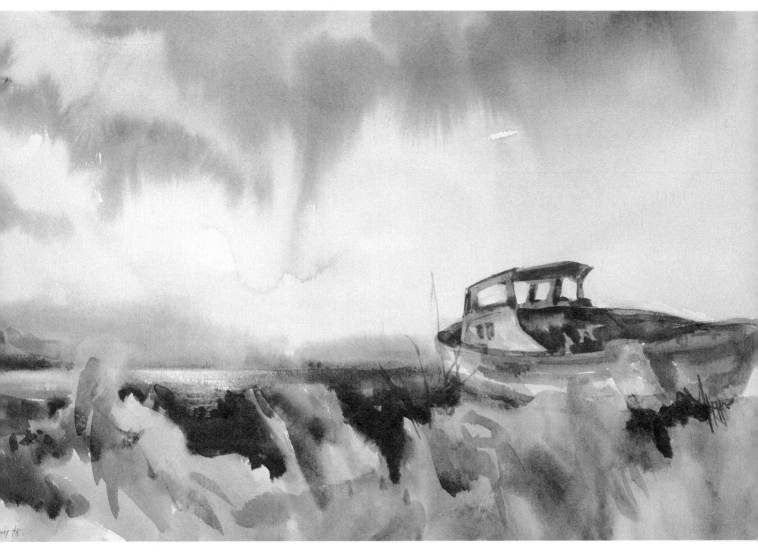

The Derelict **Virginia Avery**

New England artist, Virginia Avery, says that she is happiest when she is painting on location. She likes to be where it's at! Here in "The Derelict," Virginia employed the wet-in-wet technique for the sky and background. She splashed some color into a wet area and let it run to achieve the effect of an impending storm. The foreground is made up of broadly massed areas of warm tones that suggest wind-blown marsh grasses. Note the repetition of the sky and foreground colors in the boat. This helps to unify the painting, and relate all parts to the whole.

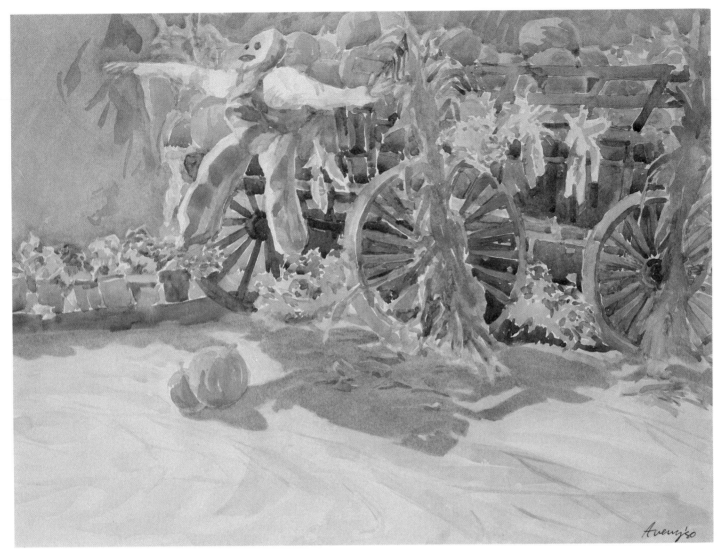

Pumpkin Wagon **Virginia Avery**

The artist told me that she had washed out foreground shadow at least six times before she settled on a final color, value and shape. (See, you *can* repair watercolor!) It is a dominant component of the composition, and therefore must be just right or it could take over the whole composition. As it is, the purplish color is the element that carries the viewer's eye around and through the painting.

This time the artist used the direct painting approach. That is, she first drew the composition, and then worked directly with the paint on dry paper. This procedure gives the artist crisper edges, and somewhat sharper definition of shapes than does the wet-in-wet approach.

Daffodils and Daisies

Judith Campbell-Reed

This painting combines realism with a semi-abstract quality that I often seek. It was done using the technique we first learned in painting skies; the wet-in-wet wash. I started by wetting the entire paper and splashing on the colors that were visible to me in the arrangement before me. I then tilted the paper and let these colors flow. When the pattern of color looked pleasing, I laid the paper flat and let it dry completely. Then I went back, and with pencil lightly outlined the daisies and daffodils in the places where I wanted them to appear. To complete the painting, I developed both negative and positive areas.

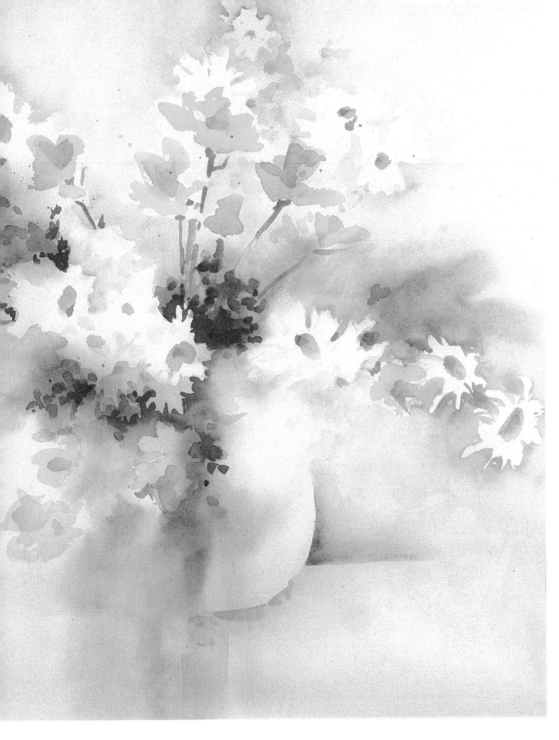

Since I wanted the daisies to stay light in value, I painted a deeper tone around them to set them off. The daffodils I splashed in with pure cadmium yellow, and then touched them lightly with cadmium orange while they were still wet. The leaves and stems were directly painted. That is, I painted the actual forms and shapes directly onto the paper. The vase and the suggested table were negatively indicated. The effect was pleasing to me; recognizable suggestion of daisies and daffodils that the viewer could then complete according to his or her own wishes or feelings.

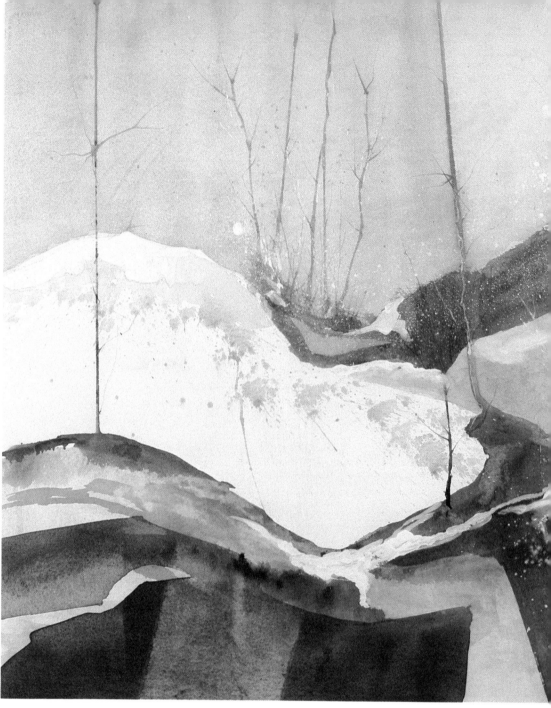

Landscape Forms **Judith Campbell-Reed**

"Landscape Forms" is a painting with a story that should be a
help to you. The result excited me because it was a giant step in a
direction I had been wanting to go, that is abstracted landscape.
The finished piece was rejected from a local show, and later ac-
cepted into a prestigious regional show. So much for getting into
shows; it's whimsical. Don't be discouraged if at first you don't suc-
ceed. On the other hand, as one friend said, "If at first you *do* suc-
ceed, don't act too surprised!"

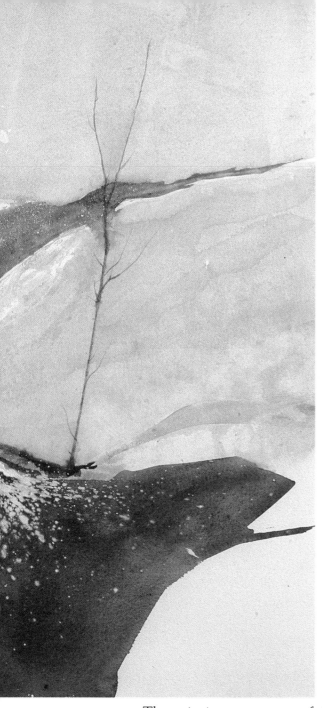

The painting uses many of the techniques that we have discussed. The white splatter is done the same way we did the splatter on our dunes and rocks. I used a very thin mixture of Chinese white; thinned because the white was too white, and in its pure state overpowers the picture. The texture in the foreground area was done by blotting the damp paint with loosely scrunched toilet paper, the way we made cloud patterns. The sky patterns were created by rolling the toilet tissue roll directly across the sky areas in random directions. The result, I feel, suggests the New England landscape in winter. At the same time the picture has abstract shapes, line, color and value in a pleasing arrangement.

Pitcher-Picture **Judith Campbell-Reed**

Arranging shapes in a still life is a constant challenge. Of late I have been fascinated with the position and contrast of white objects, especially pitchers. Over the last two years I have arranged and rearranged my collection of white things as the basis for many compositions.

This realistic painting depends on the arrangement of shapes, the use of texture, and the areas left empty for its effectiveness. In this regard the major problems are as abstract as a non-realistic interpretation.

I started by drawing what I saw before me in pencil. Then I started to paint directly. The subtlety of white objects against a white background had to be maintained. Therefore, I would often paint light washes, laying one area of color down, letting it dry, and then laying in another. Other times I would wet an entire shape with clean water, just drop in color, and let it flow (controlled wet-in-wet). The busy contrast of the striped drapery against the large white forms excited me, and the yellow lemon provides an element of interest.

Specific Techniques

This chapter is planned as an easy reference to some of the techniques mentioned in the step by step demonstrations. Learn each technique at the time you are doing the painting that calls for it. Don't try to learn them all at once, and then try to recall a given one when your picture is rapidly drying. Practice them with leftover paint on your *good* paper. The reason you should practice on good paper is because you need to know how the paper will react so there will be no surprises when working on an actual painting. With that in mind, I have presented each demonstration in the order that they appear in the painting chapters. At the end of the chapter are a few additional tricks that you may add to your paintings to complete an idea, or to give it a little sparkle.

It's always a good idea to practice the new techniques first rather than experiment on your actual painting. The best way to paint a tree is by really looking at a tree, but don't do that now. First draw a tree from memory. Most people have a "tree pattern" in their heads, a stereotype, if you will, that we unconsciously repeat every time we draw a tree.

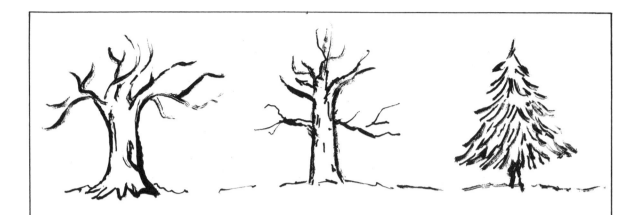

Look at your tree. Does it have some (or all) of these patterns? Always keep this first tree so you will never let it appear in one of your paintings, or, worse, have it repeat at regular intervals across the surface of your landscape! Now go look at some trees. Observe how they branch. Do they fork, or, as in the case with pin oaks, larches, and evergreens, do they have one single main trunk with the branches coming out almost at right angles to the trunk? Also observe the regularity, or most often the *irregularity*, of their shapes and the *spaces* the branches and leaf clusters create.

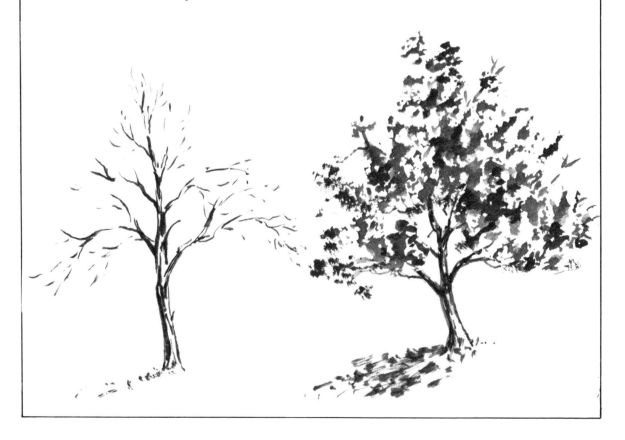

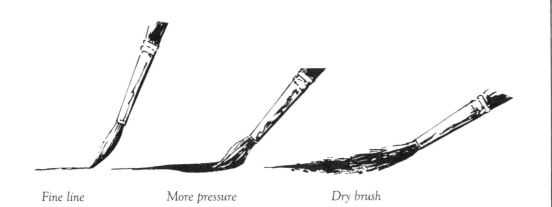

Fine line *More pressure* *Dry brush*

The fine watercolorist, Jack Pellew, says, "When painting a tree, always leave room for the birds." He means that trees are not solid. Air and light pass through their branches, and to make your tree believable, you should see bits of sky through the leaves or branches. So, even if "only God can make a tree"...we'll still give it the old college try!

You need:
 Scrap watercolor paper
 A natural sponge and a few 1 to 2-inch lumps torn from it.
 Some paint—any color
 A brush—either #12 round, a rigger, or your 1-inch aquarelle
 Water
 To observe—*deciduous trees* (oaks, maples, birches, etc.; trees that annually lose their leaves)
 Start by thoroughly wetting your sponge with clean water. Then squeeze all the water out so your sponge is damp. (Wipe the excess water off your fingers so you won't drip onto your painting.) Rub a piece of torn sponge (about the size of a walnut or smaller) into your paint and print some irregular sponge marks in upper tree-shaped areas on your dry paper. Keep rotating your sponge so that the shapes you print are not repetitive.

Now look at your pattern. Is it airy? Can you see the paper through the spots of paint, or did the paint and water run together in large blobs? (Incidentally, such runny effects can be useful later for other objects, but not here: it means you used too much water!)

When you have created some nice, light, airy patterns, you are ready to add some branches and a trunk. Use the same color you used for the leaves (tree trunks are seldom brown; most are shades of gray.) Exact color is not important at this point: value (the lightness or darkness of the color) is.

Start at the bottom and let the trunk of your tree and branches grow up and out. Hide some of the branches behind a few of the leaf masses. You never see all of the branches when the tree is in full foliage. Quite often some of the trunk is obscured as well.

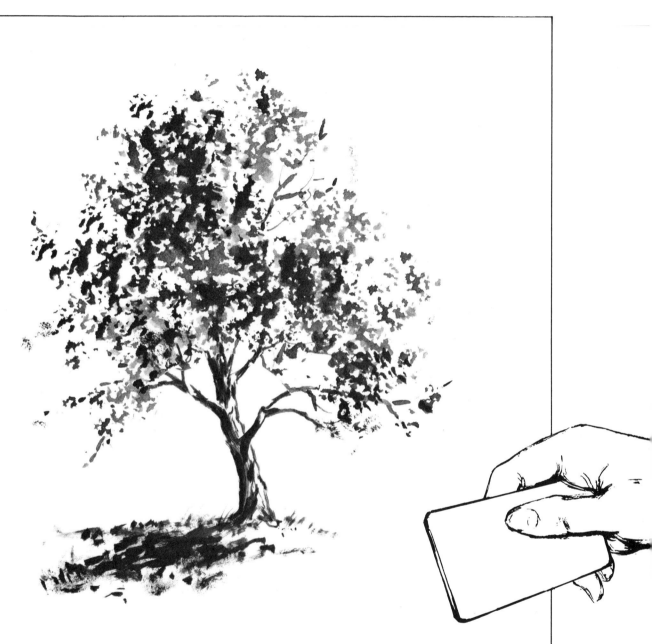

Let some of your branches peek out beyond the leaves. One of the reasons it is important to draw from the bottom up, and from the inside outward is that you will have a more flowing, natural-looking tree. Doing it in the reverse, starting at a fixed point and coming in may make the tree look too stiff. If your tree trunk looks flat, it may help to add a bit of texture by scratching it with the end of the brush or a credit card. Push with the card held as shown.

Evergreen Trees

 As a New Englander I am familiar with varieties of pine trees. My knowledge of palm trees is limited to seven days in Bermuda and *National Geographic!* However, the techniques I will show you will produce both. Incidentally, paint what you are familiar with. I don't paint canyons or deserts because I am not living in such surroundings. A landscape painter, like an author, is most believable when working from direct experience. You can't fake it! But back to the subject at hand...

 Make sure your sponge is clean and damp and that you have wiped off your fingers. Pick up some fairly intense color on your sponge and start at the center and at the bottom of where your tree will be and flick out and up! Go back to where you started and flick out and up again in the opposite direction.

 Keep flicking your way up the paper until your tree is as tall as you want it to be. Make sure that your strokes are directional but irregular. If the shapes are too symmetrical or perfect they won't look real.

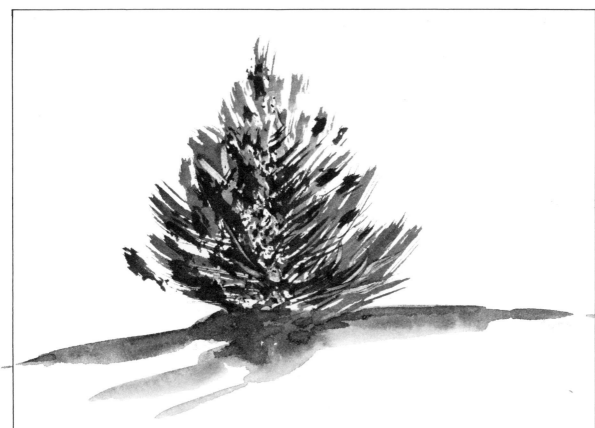

To suggest a trunk and some branches, use the tapered end of
your aquarelle brush or the corner of your credit card or a single-
edge razor, and scratch a jerky line from the bottom to the top. To
add a few branches, scratch from the trunk line to the edge of the
branch pattern. If your lines disappear, the paint is too wet. Wait a
minute or so and do it again. If, on the other hand, your paint has
dried and scratch marks don't appear, wet the tree lightly to loosen
the paint and then scratch in.

Remember to look at trees! You seldom see the whole trunk
and all of the branches, so after you have scratched in a trunk,
wait until it dries and then with your sponge flick a few masses
back over the trunk.

Palm trees are done in a similar manner. Start at the center
and flick outward with your sponge. Make sure air and light can
pass through the palms and that you haven't made even umbrella
shapes! The trunk should be painted with a long quick stroke and
then textured if necessary with your brush end or credit card.

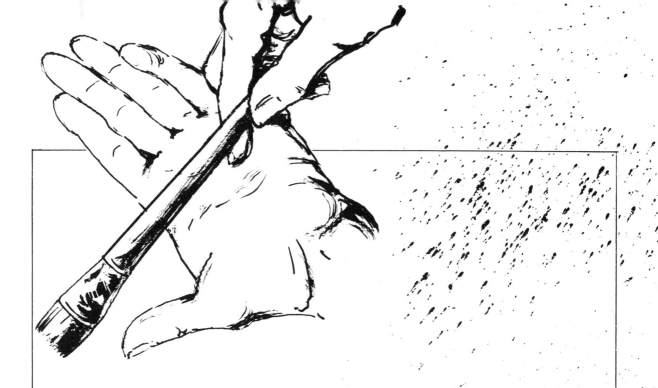

Splatter

 "Me and splatter don't get along," said a friend and student one day as she labored over the splatter technique that was hitting her face, the walls, my cat; in short, everything but the paper!

 Splattering is a handy technique to know. It is useful in creating sandy or pebbly areas, texturing rocks, sparking up a floral or still life, texturing a background or foreground without intruding on the subject, softening fields of flowers that look too perfect. It can be used in a number of ways...and it can be overused. Learn how to do it, but don't depend on it for everything. Splatter can be applied with color, on wet or dry surfaces, or it can be done by sprinkling clean water into drying areas for an interesting diffuse textural quality. Once again, use it—don't abuse it.

 There are two things to master when splattering: how much water to use, and how to get proper direction and size of the spots you are applying. The secret is practice, patience and determination; the first being the most vital.

 When learning to splatter, it is a good idea to get *everything* out of the way or covered up. You'll find paint does fly around a bit in the beginning!

You need:
 1-inch aquarelle brush
 Clean water
 Lots of scrap paper (newsprint or old paper bags will do)
 Old paint you want to use or any colors you want
 A blotting sponge or old towel

Wet your brush thoroughly and pick up some color. Wipe or
blot your brush on the towel or damp sponge you use for the
purpose. The idea is to remove *some*, not *all* of the water. Hold
your brush *loosely* near the end of the handle as shown in the
diagram. Using wrist action (the same movement you use to
shake down a thermometer) *lightly* pat the flat end of the metal
ferrule against the *soft part* of your palm between your thumb
and forefinger. Hold your flat, upturned hand about three inches
above the paper. If you hit the bone at the base of your forefinger it
may start to hurt a little in a few minutes. Continue patting your
brush against your hand until you start getting splatters on the
paper. If you have too much water the paint will fly upward in your
face, and across the table, if you have too little water it won't
splatter at all. Practice until you get fine, even splatters where you
want them on your paper. The size of the *splatter* is determined by
the amount of water in your brush.

The value of the color you use is important when you splatter—
too light, you won't see it; too dark, it will stand out like a sore
thumb!

After you master getting the splatter on the paper, and in the
sizes, values and intensities you want, you are ready to learn how
to direct its passage. Directional splatter is particularly effective
when used for sand dunes, hillsides, water edges, etc. Your splatter
should go with the direction of the painting. It is not good to have
your dune flowing south and your sand appearing to be going east.

Directional splatter or splatter with tails

Holding your hand about 3 inches from your paper surface, turn your hand in the direction you want your splatter to flow. Put your brush against your flat hand in that same direction. To get the tails to come directly down towards you, face the palm of your hand away from your body and pat the brush. The tails will come straight down. Remember, when you are splattering, *keep your wrist loose!* Your motion should come from your wrist, not from your shoulder.

The splattering I've described was with your flat aquarelle brush; it gives a broad splatter. Round brushes can also be used for splattering; they give a long, skinny, somewhat curved line of splatter often used in flowers or fields or for accent areas.

Finally, if all else fails, you can splatter with an old toothbrush. After putting paint in the bristles, flick the bristles with your index finger over the area to be splattered. This will work, but the danger of dripping into it with water that accumulates on your index finger is great. (Continually blot your fingers off!) Also, you will get large, round areas with no direction when using this technique. It is, however, a good way to add snow (using white paint) to a finished *dry* painting. Be careful of those drips from your fingers, though; there is little joy in having a 47-pound snowflake in the middle of a gentle snow scene.

People Strokes

"Different strokes for different folks" is a familiar line, but sometimes the addition of a figure or a group of figures is just what you need to supply a center of interest and pull a painting together. And while the subject of figure painting is big enough to fill volumes, we can learn to add small figures to our landscapes with a few well controlled indications of value and color.

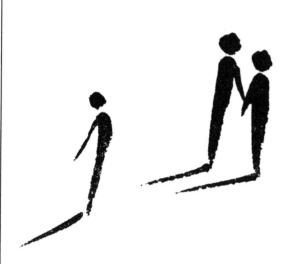

People can be suggested by making a round dot and a longish wedge-shaped dash just underneath it (almost like an upside-down exclamation point). To accomplish this a round brush is the easiest tool to use. If you have one, a #12 is good, but the corner of your aquarelle will also work satisfactorily if you are careful. Keep in mind that adults are on the average about seven heads tall, and a child is proportionately smaller. So, when you make your dot for the head, keep it fairly small or you may end up with a "pumpkin-head." Arms can be added with a line whisked in the direction that you wish.

Seated figures look like this.

Shadows are just long horizontal dashes or strokes that follow the contour of whatever they are cast upon.

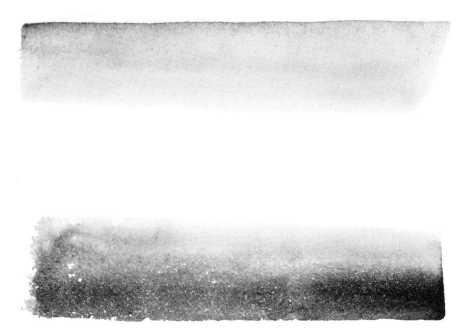

The Bucket Stroke

Valfred Thelin was the first person to demonstrate the bucket stroke to me. It is useful when you want to paint anything that requires a graded value. It can be done with a single stroke.

Using your 1-inch flat aquarelle brush, fill it with clean water, and tap out the excess on your towel or your damp sponge. It should be wet but not dripping. Now, pick up your desired color on *one corner of the brush only!*

Place your brush on dry paper and pull it either vertically or horizontally for two or three inches. The result will be an inch wide stroke that is on one side dark with your color and on the other, a light value of the color.

Now make the actual "bucket." With your clean brush corner loaded with clear water, and dipped in saturated color as noted above, pull a 2-inch long slightly tilted line down towards you. The strongest value should be on the left-hand side of your line. Don't add any more color; turn your brush over, so that your color is now on the right, and make another 2-inch line that slightly overlaps the inside of your first line at the bottom. With the dark color loaded edge of your brush indicate the bucket's bottom line and handle. Now the fun begins. While your bucket is still wet, press the side of your *fist* into the wet paint—Voila! instant texture! By the way, the old "fist-in-the wet-paint" technique works well for rocks texture too.

The bucket stroke also makes dandy water horizons. Have you ever noticed how on a clear and bright day there appears to be a dark line at the horizon? I'm sure there is a technical explanation for it, but getting the effect is the only point of interest here.

To make a water horizon, pull your brush horizontally across your painting with the dark corner of the brush at the level that you want your horizon, and the clear side nearer you. The result can be most effective.

This shaded stroke is good to use wherever you want to create a light and dark area quickly and without overworking. For instance, it's a good stroke to use when you want the effect of the roof overhang shadow on the side of a building, or the gunnel shadow on a boat. You'll find many more uses for it.

Shadows

 Shadows can be made with a few suggestive lines or dashes with your brush. Outside (landscape) shadows should all go in the same direction, in agreement with the position or indication of the light source (generally sun or moon). Shadows should follow the contour of the objects on which they fall. A general rule for shadows is to use the color of the object and mix a little of its complement into it to create a neutral gray. This changes somewhat if you are painting a snowscape; then the shadows will often look more bluish.

 Just a dash or a slash with your brush is probably all you need. Shadow areas generally should not be as detailed as the object casting it. If you leave the shadow edges loose and undefined they usually look more real, and not cut out and pasted on.

It would be easy to think of these little tricks as "instant art," and in many ways they are; but knowing them is important for beginners. They will help you create a feeling of success with your first paintings.

I referred to these techniques as a bonus, and indeed they are. Certainly they can be subject to overuse. Be aware of this fact and think about how they affect your picture. Knowing how and when to use special techniques will allow you to add professional flourishes to your work from the start. Think of them like aspirin; handy when you need them, but don't use too many at a time!

12

"Out of the Nest" — Making your own paintings

If you have done all the exercises we have covered, you are now ready to start doing some work on your own. It is hoped you have practiced these chapters more than once. Also, you should practice the techniques presented in the chapters just by themselves. For example, the splatter technique took me over a month to master.

Before you start making your own compositions, I'd like to offer a few words both in review and in warning. As you know, this book was designed for the true beginner. I remember well the frustration of encountering books and instructors that were way over my head. It took an experienced teacher to show me the basics, and in many respects I am still learning them. It all sounds so simple, but the coordination between eye, mind and hand can only be perfected through practice. What you have learned so far are some of the essential procedures necessary to paint in watercolor. Keep practicing them as you proceed. The next step is to start making your own paintings using these techniques.

1 *Drawing "on location" or from memory*

Many of us have a favorite spot in our locale or in our minds that we have always wanted to paint. The trouble with beginning painters is often that they try to paint *everything* they see at that spot. Every tree, rock, fencepost, leaf, bird, cloud and blade of grass. That's what cameras with their assorted lenses are for! Painters are not cameras and we should not try to create photographs. As painters we need to learn to focus, isolate and select. A device designed to help you simplify the complex panorama is the "little frame." It is made with a piece of cardboard about 5 x 5 inches with a 1½-inch square cut in the middle. Actually, no special equipment is necessary—you can accomplish the same ends with your two hands. (See above.)

Shut one eye and hold this device up in front of you. Look through it, and move it around until you get a pleasing arrangement. Try to include a center of interest (that is not in the center of the picture) and some interesting background. When you are satisfied you have good picture material you are ready to start your drawing.

Keep your first sketches "loose" by holding your pencil near the eraser end, not up near the point, and draw with your whole arm, just making indications for where each element of your composition will be.

This may look pretty abstract but resist the urge to draw in details. Remember, the real job of the painter is not to factually describe the scene, but to record a personal reaction to it. Sometimes, you may find it helpful to make quick "word notes" such as "dead tree, purplish sky, purple rocks," etc., right on the paper. You are in good company using this technique. If you read Leonardo da Vinci's notebooks you will see he did the same thing.

After you've done your drawing (lightly, of course), with a soft pencil (4B-6B drawing pencil is recommended), avoid erasing as much as possible. When you must take some lines out use only your kneaded rubber eraser. Your first step in painting is to *think*: "*How will I approach this?*" Sky first? Land first? Sky and land together? For landscapes it is generally advisable to develop the background first, then foreground. With more experience you'll sense the proper starting point.

Remember, as you paint and when you are done, to step back and look at your work. Also keep your drying time clock in mind. Painting a tree over a sky that is not completely dry may result in unwanted blurs. Sometimes such blurs are fine for background trees, but if you want a sharp, crisp edge to stand out in your foreground you'll have to wait until the area is dry. Impatience is the curse of the watercolorist!

When you feel you have gone as far as you can, stop. At this point it may help to review the chapters we've covered and see how to make any corrections you feel are necessary. Don't *overwork*.

2 *Painting from a photo or slide*

When you can't get out to draw directly from nature, photographs and slides are a good painting aid. Your own photos are best to use because you took them and they are your own. Many artists travel with a camera and snap pictures for use in future paintings. The camera is particularly helpful in recording specific elements such as details of a house, boat or landmark. No matter what your source, it is always essential to isolate and simplify when you come to your final painting.

The most common problem in using a photo is that the beginning painter consciously or unconsciously tries to copy unnecessary details. If you become enamoured of accessory items your main picture elements are bound to suffer. You will be limiting your vision to studying the leaves and fail to "see" the larger, more majestic forest. If you do, you are doomed to failure before you begin.

Once you have decided upon your composition, *think* about how you will proceed. With a drawing? With a wet-into-wet approach, or a combination of the two? Plan first and then proceed. Don't be dismayed if your painting begins to go in its own direction. Follow it and see what happens, and finish it up the way it wants to go. Some of my best paintings have been paintings that started out as one thing and ended up as another.

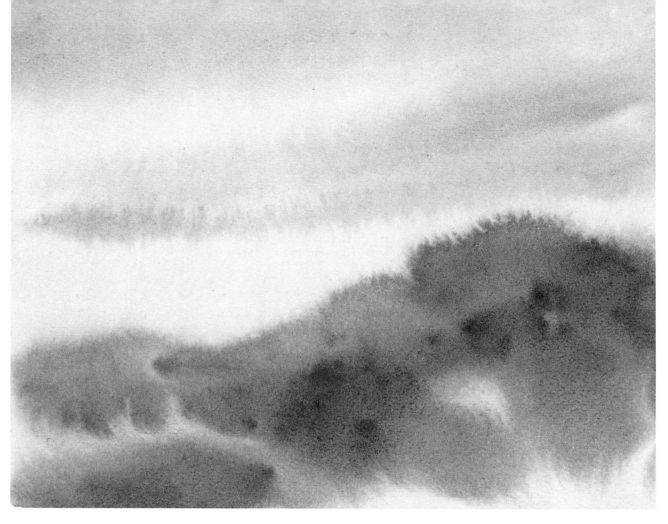

3 *Inventing your own painting from "splash"*

This is fun and sometimes harrowing, but you should try it sometime. It's a method of starting I use a lot. It works like this: Starting with a thoroughly wet paper, I choose two or three (no more) dominant colors, and then drip them on or apply them in a few broad directional strokes and let them run a little.

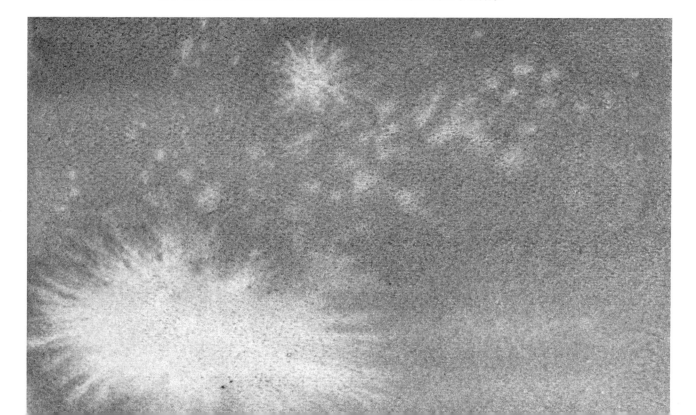

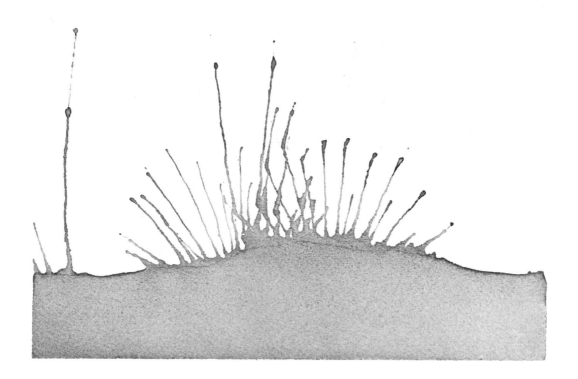

After you do this, stand back and let the painting suggest further direction. Is it a landscape, seascape, floral or abstract? Splatter some color or some water into the drying paint, and see what happens.

Try partially wetting the paper, dropping paint into the wet area and then tilting the painting so you get some interesting planned or unplanned drips. Now use them. Maybe turn the paper upside-down and blow on the drips while they are still wet, or pull them into tree branch-like patterns with the end of your brush, or a palette knife or a credit card.

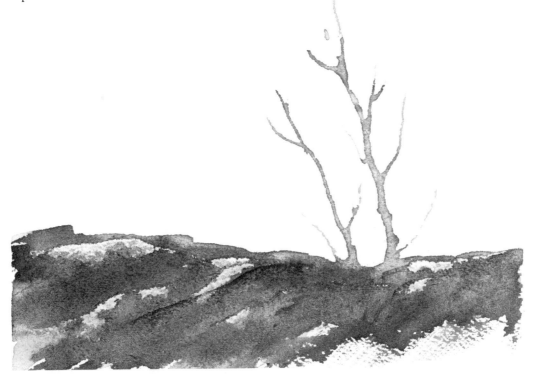

In large areas that look a little flat, you can roll untextured toilet paper across the area while it is still wet, picking it up immediately, of course. This often creates interesting shapes.

Lightly sprinkling water or coarse (kosher) salt into damp paint produces a crystalline pattern; useful for snowflakes, flowers, distant trees, flowering trees, frost patterns and wonderful abstracts.

Don't overuse it.

When something is new, successful and fun, we tend to want to try it for everything.

I remember learning a brush stroke that was perfect for crevices in rocks, and happily repeating the same stroke all over the paper. Result: a repetitive, boring disaster. No matter how beautifully individual techniques may be painted they, in themselves, do not a picture make.

If you still experience difficulty in getting started, do what I suggested earlier. Go through the step by step chapters using different colors. Try different color combinations. For example, repeat chapter 4, using cadmium orange and warm sepia only, or the sand dune painting in ultramarine blue and burnt sienna. Soon you will find that inventing color schemes is fun, and more important, that colors don't have to be "real looking" to make a good painting. If you are doing a landscape, the values must work; that is, the distant objects should be less contrasty in value than the foreground objects. Color is always relative. Try doing a landscape using purple, green and blue. Blend these colors in a light value for the sky and do your foreground in stronger values of these same hues (see glossary).

By experimenting you'll discover some wonderfully imaginative color combinations. You will also come across schemes you won't want to try again. The creative process is never a sure thing.

If, in the experience of creating a monster, there is one little section that seems to sing while the rest groans, cut out the good and save it. You may be able to mat it as is, or use it as an inspiration to make another painting from it.

Are you getting my gist? You'll never win if you don't play the game. Just start out slowly. Don't try for magnificent paintings before you know what the color will do or how the paint will react.

Some beginning artists want to move into abstraction almost at once. My feeling is that to be a successful abstractionist, or semi-abstractionist, you must first be able to render fairly accurately what is before you. Only then will you be ready to move on.

I have currently been doing landscape abstractions and found myself lucky with one or two, but then I discovered I was only repeating those first successes. I realized I had to go out and work directly from real rock formations before I could make my abstractions feel solid! So for months I rendered, drew and painted realistically the granite extrusions that abound in the Quincy area of Massachusetts. Only after I had internalized the look, feel and texture of those rocks, could the experience be reborn in fairly convincing abstracted forms.

13

"Splashdown" — Repairing Goofs

Several times I have mentioned not to let a mistake get the best of you or your painting. It happens to everyone sometime, and to some of us more often than others. It's not what we did incorrectly, it's how we get out of it that counts. Most things are fixable. One memorable example for me was when I was demonstrating and inadvertently cut the paper in half at a slight angle from top to bottom just to the left of center! The audience gasped. I taped the pieces together on the back and continued my painting; a house on a distant hill. When I had completed it, I added a telephone pole in the foreground along and over the cut, put in some crossbars, and a couple of directional telephone wires and made a far more interesting painting than I had intended. Mind you, I don't recommend slashing your paintings as a compositional device; just remember that things usually can be fixed with a little ingenuity and a touch of humor.

The following common painting problems are not necessarily listed in order of frequency or complexity: we all have our specialties. These seem to be the most commonly occurring problems for watercolorists who are just learning and also for those who have had more experience. No one is immune from disasters!

1 *Big white spot in the middle of the sky (or anywhere else)*
This usually occurs if you have dropped water into a partially dry area or touched it with your brush or your finger. Sometimes it is possible to turn it into something useful in your picture such as the sun, moon or a light. If you can't disguise it, then you had better cover it up. Dampen the spot and about a half-inch beyond with clear water. Lightly drop the surrounding color into the middle of the spot and let it spread outward; adjust the color if necessary. Lightly blot the outside edge of the wet area with tissue so you don't have a hard-edged "balloon" in the middle of your area. *Let dry.* Repeat procedure as necessary.

2 *Bleed back*

A *bleed back* is caused by water or moisture from a wet portion of your paper creeping back into a drier section. This causes a ruffle-edged bubble-appearing shape. This may happen along the edge when water from your masking tape or your mixing area splashes into a drying section. Remedy: Let the whole thing dry *thoroughly*. Use a blow dryer if you are not sure, or wait an hour. Then with a damp, stiff brush or toothbrush, scrub lightly at the wobbly line around the shape and blot *at once* with tissue. Look at what's happening. Is that hard edge a little lighter? If so, repeat the process again and again, always blotting right away until the line is *hardly* visible. From a normal viewing distance of 6-12 feet the line should not be bothersome. Don't wash out so much that you have a white spot! Patience is the key here, as it is with every painting you do!

Note: Bleed backs at times can be useful. They may create neat trees or flower shapes in wet-in-wet paintings.

3 *Unplanned splatters*

A. Tiny pinhead size splatters can usually be ignored. At times they will flick out with the corner of a mat knife or razor blade, but, as a rule, it is best to leave them alone.

B. Medium-sized splatter spots that are visible from a viewing distance are more difficult to handle. Possibly they can be turned into birds or some other appropriate forms. If you are painting a landscape, the lift out method also applies, but this time use the tip of a pointed brush (not the hairy end, but the handle) or a toothpick. Put a *drop* of water on the spot. Wait ten seconds and then jiggle the spot a little bit (the paint will have loosened) and blot immediately. Check your progress and continue until the spots are no longer visible.

C. Big splat, dropped brush, unplanned cat paw print, and the like, are another matter. Unless you blot it the *moment* it happens, wait until the area is *absolutely* dry. Then proceed as before. Wet the splat and blot or lightly scrub with a stiff brush or toothbrush. Blot constantly until the spot disappears or is light enough to live

with. If the spot is still offensive, try to adjust your composition to incorporate it. Another flower, a tree, a bird, a cloud, whatever. Be inventive. Some of my best paintings have been disasters that were retrieved. Believe it, it's true. It's not what you create but what you *save* that's often the most exciting and rewarding. That's growth!

D. Any unplanned spots. I have had dogs and cats decorate my paintings. Children have sneezed on them and I have dropped them and stepped on them. All were retrieved. Don't give up or be overly dismayed.

4 *Color too bright*

Sometimes a painting turns out well except that one area appears to jump out at you. The background looks like the foreground because the color is too intense in the wrong places. There are two solutions:

A. Lift out some color the same way you'd lift out an unplanned splat. Wet it, scrub it lightly, and blot. Be careful of the edges of your wet area or you'll have a light spot. Wet a larger area than you plan to lift out. Scrub at the part you are unhappy with, lightly scrubbing into the surrounding area so you don't create a hard edge. Blot the whole thing. Stand back and look at it. Then do it again if necessary. Whenever you are repairing a problem, take small steps rather than try to correct the whole thing at once. Go slowly.

B. The other approach is to wash the area with its complementary color. (See glossary.) A wash in this instance is a *thin* film of color laid over *dry* paint *once*. Mix up a pool of light color. Fill your brush so it is loaded but not dripping. Tap out excess moisture on your old towel and brush the color over the problem area, blotting the edges with tissue. If the color is too dark, blot the whole thing. A thin film will remain. If the color is not changed enough, wait until it dries and lay on another film of color. Keep going until it's right. If you overdo it, let it dry. Wash a layer of clean water over the area and blot it at once. You should be alright. Remember, patience. Let it *dry* in between layers.

5 *Crumpled painting*

Children, animals and even artists occasionally drop, step on, and inadvertently crease a good painting.

Solution:

Minor crease—Spray the back of the paper lightly with clean water. A plant sprayer works well. Lay on a clean towel and cover with another clean, dry towel. Lightly iron with a steam iron on *low* setting.

Major crunch—Re-stretch the painting. Use a clean piece of masonite, homosote or plywood for a support. The material should be well coated with polyurethane to keep moisture out. Lay the painting face down on the support board. Wet the entire back thoroughly and mop up the edges. With moistened brown butcher tape, stick the painting face down on the board. Let it dry for twenty-four hours. Cut it loose with a mat knife. This paper shrinking process should pull out most of the major wrinkles.

6 *Grease stain*

A real toughie. Try using a warm clothes iron and paper towels. Lift out the grease gently with the tip of the iron. The minute you see any grease on the paper towel, use a new section. You can also leave some cornstarch on the stain overnight. *But* you may be able to paint over the grease stain if you add a little Ivory soap to your paint. The soap will cause the paint to adhere to a greasy or waxy area.

7 *Mashed brushes*

Did you goof and leave your brush standing on its head so it now has a permanent wave?

Wet your brush and stroke it on a bar of Ivory soap. When the bristles are soapy, smooth them with your fingers to their original shape and let dry *thoroughly*. Then wash out *all* soap (many rinsings) and shape it again with your fingers. Your brush will usually come back to normal.

If one of your children uses one of your sable brushes to paint an airplane, all is not lost. Use furniture stripper or paint remover for soaking the brush until all the paint or goo is out. Wash the brush and use the Ivory soap treatment.

8 *Poor composition*

If your painting has two or more good areas that seem uncon-
nected, you have a compositional problem. Or, maybe you have an
unfixable disaster in one area. One answer may be to "crop" your
painting. That is, cut it down so that the good parts work. Some-
times this results in two or more smaller, but better paintings from
the one large disaster.

Incidentally, the purists have a fit about this procedure because
an artist is supposed to make effective use of the entire surface.
Rules again! Don't be intimidated by such dogma. If it works, then
go ahead and do it. Here's how. Take four three-inch strips of white
paper (old mat board does nicely), and lay them around the good
areas of the painting, making a frame. Move them around until
you get a section you like and mark the inside of the space on your
painting *lightly* with a pencil. Now move the frame strips outward
about ½-inch and draw your cutting lines. Remove the strips and
cut your painting along the lines you have drawn. The inner marks
tell you where the final mat will fit. Before you throw the rest
away, check other areas for "good spots." You may have another
attractive mini-painting.

9 *Deeply scratched rocks, grasses or trees*

This is trouble. If you have scarred the surface of the paper, you
are stuck with these marks. Often they appear too dark, too light,
or generally out of place and intrusive. One way to deal with it is
to add more. If your scratch is an isolated one, make it look like a
clump of something. If it is grass that has grown too long, maybe
you can turn it into a bush or a tree. If it is in an area that you can
cut away and still save the painting, then do that. And if none of
these things work, turn the paper over and start again.

10 *Too dark and won't wash out*

Let's say, for example, that you have painted a hillside and it looks
like wood: heavy, flat, no visual undulations. You can lighten
grasses, trees, and even still lifes by nicking or scratching with a
razor blade when they are *completely dry!* This is how I put snow
on trees sometimes, daisies in a field, or make grasses where none
existed and I needed them. This is also good for showing boat rig-

ging against a dark background. Warning—it takes practice, and don't overuse it. It can easily look gimmicky.

11 *"Something is wrong but I don't know what!"*
The solution may be to call on a knowledgeable friend. If one is not available, look at the painting in a mirror. Seeing the image in reverse sometimes helps you to see what's wrong, missing or even what's right. Turn the painting upside-down and view it in the mirror. This helps you not see the shapes and the overall design. If something is overpowering or lacking, you will see it. Finally, take it to bed with you! No joke. I do this all the time. Set the painting up so you will see it first thing in the morning when your mind is fresh. I often solve my painting problems this way. If after many days of doing these things you still don't know how to set things right. . .*the painting is most likely beyond repair.*

A beloved teacher, Harold Lindegreen, said, "It takes two people to make a painting: one to start it and one to stop it." The curse of the artist is often overworking and not knowing when to quit.

14

Showing Your Art

Where and how to show your art is a question that all artists face at some point in their careers. For some it is a natural out-growth of their education in art school—starting with student shows and competitions, and progressing from there. For others, particularly those without a formal art school background, it is a more difficult proposition, and one that involves both a search—and a risk. The search is, of course, where—and the risk is how it will be received by the viewer. While the decision to do it can only be a personal one, the ways to go about it are varied; and there is support for the fledgling artist if he/she knows how to go about getting it.

In a study I did a few years ago, I asked artists who considered themselves professionals, "How do you measure success?" and to a person they said, "Not by money!" They cited peer approval, acceptance to shows or galleries, awards, and finally money.

Let's begin with peer approval. Art can be defined as visual communication, and few (I don't know any) really paint for themselves alone. It is a myth propagated by artists who are afraid of failure. When you want to show your work—ask a friend who paints and shows—or your teacher, or anyone else whose opinion you value and trust, for an *honest* critique. Family members are usually too kind. Sometimes advice to show comes unsolicited—a friend or colleague suggests it. (Great! You're ahead of the game). But still get another opinion, or at least have a trusted advisor help you select from your work what you will show. We all have ups and downs and we are often too personally involved with a piece to make a sound judgement. Now the question is where.

Many cities and towns have art associations that are perfect places for the unexperienced artist to begin. These groups usually have regular meetings, with visiting artists giving demonstrations, group critiques, and an annual show. This is a good situation to learn new techniques. See how you measure up, and give it a whirl! Once you've gotten your feet wet and actually shown some of your work, you are more ready to strike out on your own.

Local banks and businesses often provide places to hang work. If you see art work hanging somewhere, ask if you can show yours. Sometimes you must get approval of a committee or a person in charge—othertimes it is merely first come, first served—but, to be trite, you'll never know unless you ask! You can always pretend you are asking for a friend. Once you do, in fact, start to show regularly, you will be surprised to find people coming to you and asking if you might be interested in putting your work somewhere else. The word here is exposure. The more you do, the more you will get, but you have to make the first move.

The next step for many in an art career is the juried show. This can be local or regional or even national. Each being more exacting than the last, but still exciting, and a good learning experience. These usually involve an entry fee and some very specific hanging or showing requirements: size, price, framing, subject, etc.

Artists are sharply divided on the subject of a hanging fee. I don't object to it, as I see it as a way of financing the show, covering insurance, and providing prizes to deserving artists. Some feel it is exploiting the artist—the offer of their work for exhibit is enough. You must make your own decision on that one. Information for these shows can be found in local newspapers, and some professional art magazines available by subscription or at your library. The word of advice here is: Follow the directions outlined in the prospectus of the show. If you don't—you are out before you even have a chance to get in!

Ultimately, when you have gained some local or some regional approval, and you want to move some of those treasures that are beginning to make your studio (or bedroom or dining-room, etc.)

look like a warehouse—you might want to consider association with a gallery. Galleries take a hefty commission (33-50%), but they perform a service we can't do and paint, too. They show and sell and advertise our work.

Like any other business, galleries serve different purposes. Ostensibly, they sell art; but how they sell it is something you should investigate. Broadly defined, galleries are commission-based, rental, artist-owned, or cooperative. These are different from exhibition galleries that are in civic buildings, churches, etc., whose primary purpose is to show rather than to sell.

Of the commercial galleries, I prefer the straight commission or consignment type. They carry your work at no cost to you and pay you a percentage of the sale at the time of sale or at a designated time. Define your terms and read the contract before delivery of your work. Rental galleries are not always publicly defined as such, and often charge a hefty hanging fee in addition to a commission. These galleries are sometimes not as quality-controlled as the straight commission galleries, and will show almost anything because they make their money on the rental. Again—define your terms before you sign anything. Cooperative galleries are group-run and operated and usually involve some work on your part. They can be a good bet if you are accepted and accepted their terms. Artist-run galleries tend to push the owner's work. Check on the priorities of the gallery before you sign.

With this as background, the next step is to visit the gallery and see whether your work will fit in its atmosphere. If you are a traditionalist and the gallery shows abstract expressionists, you will not be accepted, and vice versa. Check it out first. Next ask if they are accepting new artists. If they are, make an appointment.

Don't just walk in with your work. Make yourself and your work important. Ask what they wish to see. Bring what they want—work, slides, or whatever. Dress well, be on time, and be professional. It doesn't hurt at all to check out their reputation with other artists or professional organizations. Some galleries will eagerly accept new work and then pay very slowly or not at all. Be cau-

tious. Also check on gallery insurance, how they store paintings not on display, and what their display policy is, e.g., will your work be in a bin, on the wall or on the floor in a back room!

A good formula for basic pricing is: Time + materials (frame, etc.) x 2. A reputable gallery will help you price your work fairly for their market. They want to sell work so give their advice some credence.

In a lecture to young artists, I said, "Remember the three P's—be Prepared, Professional, and Persistent!" Each is valuable, and one can't and won't exist without the other. You make the paintings and you present them.

A final word on presentation. Framing is horribly expensive, but it often makes the difference between a ho-hum painting and a work of art. Learn to do it yourself to save money. Make a deal with a framer—or pay the price—but present your work well. Secure wires, corners that match, clean glass, etc. It's the final touch that will often sell the painting. Again, if you're unsure, ask the advice of a good framer. That's their business and they usually know better than we do.

Remember, a painting worth showing is worth showing well. It involves personal risk, risk of refusal, and risk of acceptance, but without risks we do not grow. Confront yourself and your work honestly, and you will grow and hopefully prosper.

15

Pricing Your Art

How to price a painting is a question asked by nearly all painters who want to start to sell their work. It's a tough question. Those first paintings, worthy of being sold, are usually precious to the artist, and if so priced—are usually priced unrealistically for a potential buyer.

I'd like to present some guidelines that might be useful to beginning and more established artists, and while time and materials are certainly a consideration, it is the finished piece that commands the price. Equally important is the market to which the piece is presented.

When I first started selling my work, I sold those first fledgling pieces at a cost that was little more than the price of the materials; as my skill, experience and reputation increased I was able to charge more.

Many artists start selling out of their studio or in local art shows. Certainly the cost of the paintings should cover the cost of the materials, canvas, stretchers, paper-frame glass, etc., and a gallery or show commission if one is demanded. The question remains, how much beyond that? The answer lies in the *real* wishes of the artist. Do you want to say you sell your art, or do you want to say you are asking astronomical prices for your art? A policy that has worked for me is to start low (reasonable for you, but low), and as you and your reputation and your recognition grow—start raising

your prices. Also, you can ask advice of someone else; a gallery director or one of the members of the Show Committee if it is a local association show, and don't get your feelings hurt!

Locale is also a factor. If yours is a low to middle income area—people are not going to spend much over 100 dollars for something original to hang on their wall when they can get a genuine artificial wood framed print, textured no less, for twenty dollars at the supermarket, or worse yet one of those "sofa sized" paintings for under thirty-five dollars that are so pathetically available. If, however, you are living or showing your work in a more affluent area, you will be able to ask higher prices.

Another factor is time. One artist will produce a really fine painting in two hours and another may take two months for an equally fine painting. The average buyer really doesn't care—and when he/she sees comparable pieces size-wise, the person is often going to go for price. Be realistic, and know your market. An inflated ego is the worst handicap an artist can have!

The best examples I can use are my own and those of other established artists I know. As crass and materialistic as it may sound—pricing by the "square inch" once you are producing regularly is the best guideline. A friend of mine, whose work sells regularly, and who consistently takes prizes for her work, sells her paintings that are roughly 30"x40" in size for four hundred dollars. Two years ago they were three hundred dollars, and a year from now they may be five hundred dollars or more. Smaller pieces are priced comparably lower.

Another question that most artists face is, "What do I charge my friends?" Since most of us start by selling to our friends, it is only fair to give them a break. What I do now is put a "gallery price" on all my paintings and then deduct a third (the gallery commission) for anyone to whom I sell "direct." That satisfies my conscience and their wallet. My answer to those people who say naively, but I can't *sell* to my friends, I say, "if you don't, you deny them the right of having your work, because you can't *give* it away indefinitely without some resentment."

134

One last comment on the "sale" of one's paintings does not involve money. And that is, always consider the 'barter' system. As an artist, I have 'traded' paintings for goods and services worth almost as much on a cash basis as I have sold for real money. Many people are often anxious to own an original piece of art, but budget wise it is too dear a luxury. Suggest a trade! I have traded my art for snowtires, housecleaning, babysitting, clothing, dressmaking, vacations and other art, and that is a very partial listing.

It is a popular fallacy that an artist can't possibly have a "business-head." Again I reiterate—be realistic, ask advice, be human; make yourself and your buyer happy.

Glossary

Here is a listing of down-to-earth words and terms I have used throughout the book. As a beginning student, I have had words like these tossed at me, and not known what they meant. The instructor just naturally assumed that I knew, and I, along with other students in the class, were often too intimidated to ask.

Aerial perspective

Color perspective. Objects in the distance look less bright than objects that are near. For example, a red barn or a brilliantly colored fall tree that is 200 feet away, will look less red, or less brilliant under the same lighting conditions than when you are standing next to them. This is because there is matter in the air that we can't actually see, but it does in fact affect our vision and how we see colors. To achieve this illusion when painting a distant object, use less paint and more water than you would use on the same object seen close at hand. You can also add a little of the complement of that color, to gray it or neutralize it slightly. Similarly, skies tend to change color towards the horizon because you are looking through greater densities of the atmospheres. Edges of things in the distance are less crisp than objects in the immediate foreground. In other words, you don't see all the rigging in a boat that is far out at sea, nor do you see nails and cobwebs on the side of an old barn that is 500 feet away from you. Beginning painters want to put in everything, and that is a common error. Your painting will be far more real if objects in the distance are simply suggested. Cameras with telephoto lenses are able to show detail at 300 feet, artists shouldn't try.

Aquarelle

A French word for watercolor.

Bleed Back

This happens when one area of a painting has begun to dry, and a wetter area crawls back and makes a light bubble with a ripply edge. This can be used effectively when you know how to control it, but when you don't it can be annoying. Avoiding it requires timing and patience. If you are supposed to wait until an area is completely dry, then wait, otherwise you stand a good chance of getting a bleed back. Getting rid of them once they occur is discussed in the "Splashdown" chapter.

Color

Under this broad heading are a number of commonly used terms. Color for the artist has three properties: **hue** (its name), **value** (its lightness or darkness), and **intensity** (its strength or purity. This is sometimes referred to as chroma). My aim is to familiarize you with some of the most basic concepts.

Color Wheel: An arrangement of the colors of the spectrum in a circle, in the order that they appear in the rainbow: red, orange, yellow, green, blue and violet.

Primary Colors: Red, yellow and blue. These colors exist in nature, and can not be created by mixing. On the other hand, from these colors you can mix almost every other color you might ever use. As an experiment, try doing a painting using alizarin crimson, ultramarine blue and cadmium yellow.

Secondary Colors: Orange, green and violet. These lie halfway between the three primaries.

> Red + yellow = orange
> Yellow + blue = green
> Blue + red = purple

Complementary Colors: Colors that are opposite from one another on the color wheel, such as red and green. Such colors, when mixed together in the right proportions, produce a neutral gray.

> Red + green = gray/neutral
> Orange (or brown) + blue = gray/neutral
> Yellow + violet = gray/neutral

Cool Colors: Green, blue, and violet; colors sometimes associated with water, ice or foliage.

Warm Colors: Red, orange, yellow; colors often associated with heat and fire.

The cool and warm properties of any color are always relative to the color with which they are associated. Although red is a warm color and blue is cool, it is obvious some reds may be cooler than others, and some blues relatively warm.

Earth Colors: Colors made from finely milled earth, literally dirt; "earthy" colors are browns, ochres and siennas.

High Key and Low Key Colors: Key means the overall brightness or darkness of a painting. High key colors are colors that tend to be light and bright and pure. They would be numbers 1-5 on a value scale where zero represents white and 10 is solid black. Low key colors are deep, dark colors, running from mid-tones to black.

Hue: Another word for color, basically its name, such as red, yellow, etc.

Opaque Color (often called gouache) are colors whose pigments do not permit light to pass through. When applied thickly over another color, they can hide what is underneath. However, when diluted with water sufficiently, opaque pigments may have transparent qualities.

Transparent Colors: Colors whose grains of pigment are very tiny and will float in the water. These colors, with but slight water dilution, allow the light of the underlying paper to shine through. When used in a glaze over another color, they will alter the color, but will still retain a transparent quality.

Value: It means the lightness or darkness of a color. It is measured on a "value scale" of grays that is frequently calibrated numerically from 0 to 10. Often the lightest gray is designated as #1—10 being black. Some artists prefer to reverse this scale so that the white is number 10 and black is zero.

1 3 5 7 9

There are a variety of "tools" you can use to check the value pattern in your painting. One woman I know carries a piece of blue glass in her painting box. From time to time, she looks at the work in progress through this glass. What it does is effectively distort all the colors that she has used, so that all she sees are the darks and the lights in terms of gray. This way she can tell if her values are "working" correctly together.

Other artists do "value studies" before they start the actual painting. That is, they do a quick sketch of the proposed work in pencil, or a single color wash, establishing the dark and light pattern before they begin.

Design

The word design is often used interchangeably with composition. I define it as the arrangement of shapes within a given space. In reality, design is the planned or intended arrangement of the elements in the composition. Good design is practically impossible to define. It most often depends on an interesting variety in the sizes, shapes, values and colors used in a picture. Until such time as you are sure of what you are doing, it is advisable to avoid dividing the picture's spaces evenly, or placing the area of interest at or near the center of the picture space.

Strong vertical and diagonal shapes tend to make the painting look active and exciting. Long horizontal lines in a painting are likely to generate a peaceful, relaxing composition.

Because there is so much to say about the subject of design in painting, I strongly suggest that you get a book on the subject and read more about it.

Glaze

A thin film of diluted color brushed over an unpainted, or thoroughly dry, painted area. Sometimes I do whole paintings using this method.

Experience will tell you how much color and how much water to use, but go slowly; a thin glaze will change your painting just a little bit. Try to go too fast and you are in trouble. And always let your paper dry out between glaze applications. If you don't, you will lift out color instead of laying it down.

Intensity

The strength or weakness of a color, i.e., its brightness or purity. Do not confuse with *value*.

Negative Space

Think of negative spaces as the spaces and shapes around and between the objects that are the subjects of your work. They are every bit as important to your design as the subject itself. In your work you should strive for a pleasing harmony between the positive and negative shapes. Look at some of the paintings in the "Gallery" section and notice how the different artists made use of their negative spaces.

Resist

Something used to resist or repel the paint.

In order to preserve whites in a watercolor painting, some artists use rubber cement, or a compound called maskoid or maskit, to mask out the areas that they plan to keep white. Later, they peel away this coating to reveal the brilliant white paper preserved underneath. This method may leave the edges a little hard. I prefer to paint around an area that I want to keep white.

The wax of candles or crayons can also be used as a resist when applied directly to the paper to repel the paint. I am not fond of either method, but you may find you like them. Kosher salt, detergent and alcohol are also resists, and add interesting textures and configurations when dropped into wet paint. (See the chapter on "Making Your Own Painting" for further elaboration of some of these techniques.)

Wash (Flat wash and graded wash)

A flat wash is a thin even film of color. When applied over another color it is called a glaze. For example, to tone down an area that is too bright you might be told to lay down a thin wash, (or glaze) of a complementary color.

A graded wash is a thin film of color that goes either from a dark value to a light one, or vice versa. This is usually achieved by starting with a brush-load of color, and adding water, but no more paint as you work your way down the sheet.

Conclusions

The word commencement signifies an ending and a going forth. That is what I would like for the reader of this book. What I have demonstrated and discussed here are techniques, "tricks of my trade," if you will. When learned they will allow you to produce acceptable paintings. The secret is to go forth: take these techniques and any others you can acquire from books, other artists, professional demonstrations—in short, anything from anywhere— and make them your own. Adapt, modify, incorporate and experiment. *Grow!*

I often say to my students, "Learning to paint is like learning a new language. I can teach you vocabulary and grammar, but only *you* can express yourself in that language."

It is important for me to be able to do a variety of paintings. I will work in landscape one time, still life another. Continuity lies in the structure of my compositions, my use of color and the techniques with which different results are achieved.

Another artist will choose one style of expression, and within that structure grow and change. It does not make one better than the other. I have had gallery owners suggest I develop a certain style, a signature, so that they can push that particular type of painting. That is not natural for me, and I have always refused. Another artist, a superb illustrator, is much less successful at other types of expression, and prefers to stay with a single style. That works for her.

As the saying goes: Now the ball is in your court. Don't push yourself in any one direction, particularly in the beginning. As you gain experience you'll find subjects you like better than others, colors you prefer, and techniques that seem natural to you. Let that happen: you can't make it happen, and if you try the only result will be that your work will probably look like someone else's.

It is natural at first to be strongly influenced by your teacher. That is, in fact, the whole purpose of this book. I want to influence you, but I want you to go on.

I owe my greatest professional debt to my first watercolor teachers, Priscilla Patrone of Wells, Maine, and Joan Dunkle. Many of the techniques outlined here are adaptations of my first lessons with them. They, in turn, developed these techniques from their teachers.

I started painting landscapes when I first started using water-colors. (I had been an oil painter for eight years.) As I gained confidence I moved on to still life, portraits and the figure, and into the abstract. Now my work is a composite. My landscapes have an abstract quality, my still life compositions are sometimes carefully rendered and sometimes are abstract collages. In other words, I have no bounds except those imposed upon me by time—family, work, etc.—but even those I try to control.

To refer to the analogy stated at the outset regarding driving a car. You know how to drive. You know the mechanics of driving. Will you only use it to buzz around your neighborhood and never leave town, or will you get a road atlas and set off across country? Whatever you do, don't just stay put in your driveway. Get up and go!

Bibliography

Betts, Edward, *Master Class in Watercolor*, Watson-Guptill Publications, New York, 1975

Corn, Wanda, *The Art of Andrew Wyeth*, New York Graphic Society, Boston, 1973

Derkatsh, Inessa, *Transparent Watercolor*, Prentice-Hall, New Jersey, 1980

Edwards, Betty, *Drawing on the Right Side of the Brain*, Tarcher, Inc. California, 1979

George, Ethel Todd, *Painting Flowers With Watercolor*, North Light Publishers, Connecticut, 1980

Goldsmith, Lawrence, *Watercolor Bold and Free*, Watson-Guptill Publications, New York, 1980

Goldstein, Nathan, Painting, *Visual and Technical Fundamentals*, Prentice-Hall, New Jersey, 1979

Jamison, Philip, *Capturing Nature In Watercolor*, Watson-Guptill Publications, New York, 1980

Itten, Johannes, *The Art of Color*, Van Nostrand Reinhold, New York, 1961

Nechis, Barbara, *Watercolor, The Creative Experience*, North Light Publishers, Connecticut, 1978

Prohaska, Ray, *A Basic Course In Design*, North Light Publishers, Connecticut, 1980

Reid, Charles, *Flower Painting In Watercolor*, Watson-Guptill Publications, New York, 1979

Wong, Frederick, *Oriental Watercolor Techniques*, Watson-Guptill Publications, New York, 1977

Wyeth, Betsey James, *Wyeth at Kuerner's*, Houghton Mifflin, Boston, 1976

Szabo, Zoltan, *Zoltan Szabo Paints Landscapes*, Watson-Guptill Publications, New York, 1977